John Shaw's
FOCUS ON NATURE

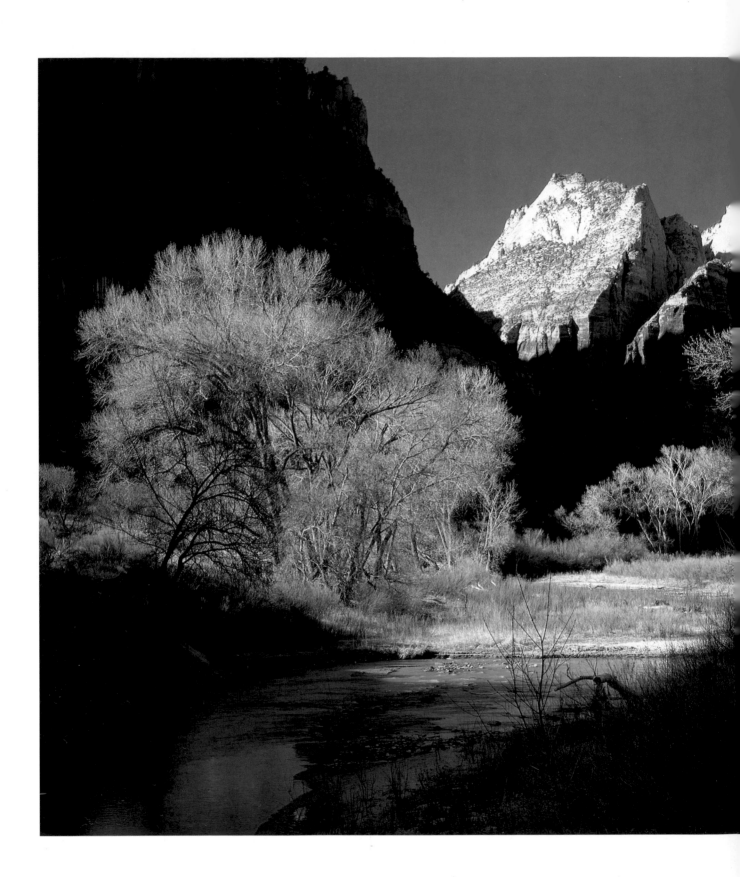

John Shaw's

FOCUS ON NATURE

AMPHOTO

an imprint of Watson-Guptill Publications

New York

JOHN SHAW is a world-renowned nature photographer who regularly publishes his
work in such magazines as *Audubon*, *National Wildlife*, and *Natural History*, as well
as in filmstrips, advertisements, and books. He is the author of two best-selling
Amphoto books, *The Nature Photographer's Complete Guide to Professional Field
Techniques* (1984) and *John Shaw's Closeups in Nature* (1987). Shaw teaches summer
field workshops across the country and leads photographic tours to a variety of
destinations.

Copyright © 1991 by John Shaw

First published 1991 in New York by AMPHOTO,
an imprint of Watson-Guptill Publications,
a division of BPI Communications, Inc.,
1515 Broadway, New York, NY 10036

Library of Congress Cataloging-in-Publication Data
Shaw, John.
 John Shaw's Focus on Nature/by John Shaw.
Includes index.
ISBN 0-8174-4055-0 ISBN 0-8174-4056-9 (paper)
1. Nature photography. I. Title.
TR721.S5 1991
7787.9'3—dc20
 91-14030
 CIP

Manufactured in Singapore

2 3 4 5 6 7 8 9 / 99 98 97 96 95 94 93 92

Editorial Concept by Robin Simmen
Edited by Liz Harvey
Designed by Jay Anning
Graphic Production by Hector Campbell

DEDICATION

*With many thanks to my friends with whom I've photographed
and shared good times out in the field. I've learned a lot from you:
Larry West, Joe Van Os, Mike Kirk, Dave Middleton,
Alex Thiermann, and John Ray—*

and in memory of S.E.—I miss you.

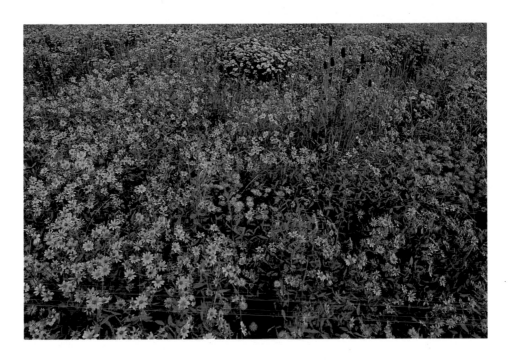

ARNICA, FLEABANE, AND CONE FLOWER
Nikon F4, Nikon 24mm lens, Fuji Velvia

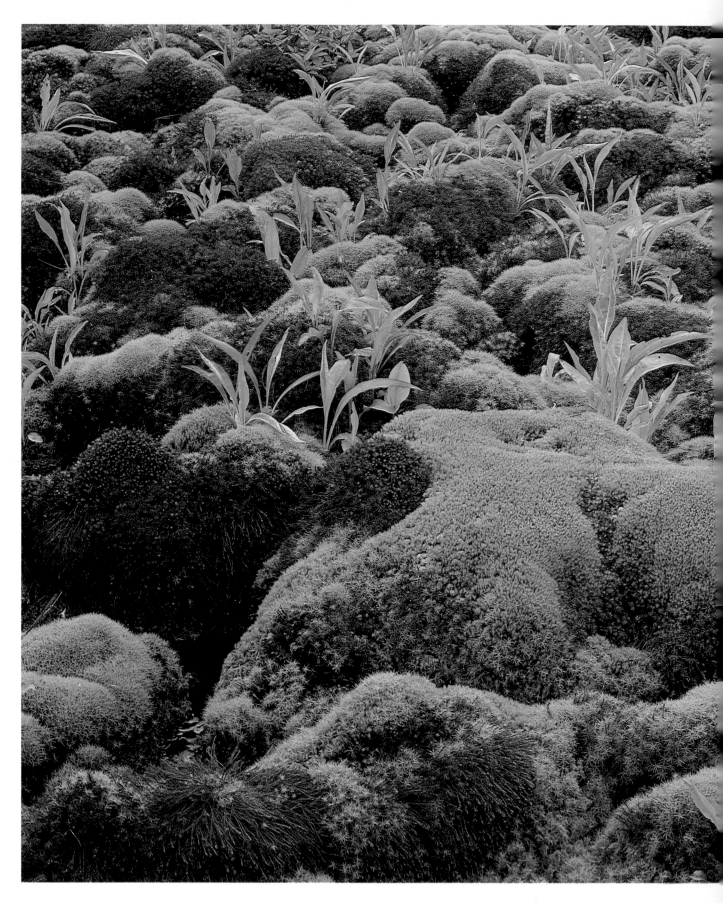

HAIRCAP MOSS MOUNDS
Horseman 985, Schneider 150mm lens, Fujichrome 50

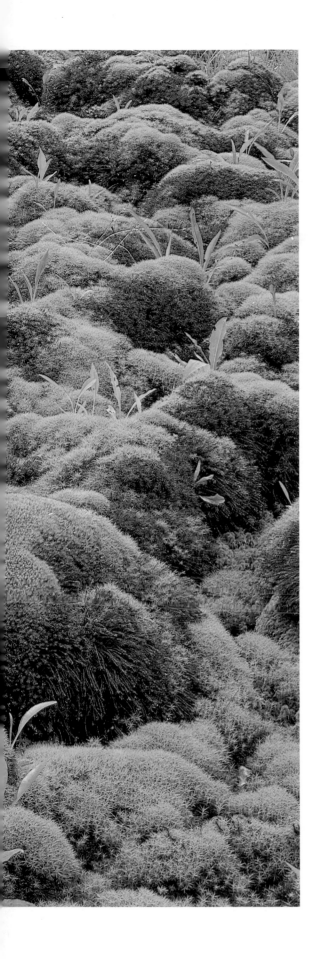

CONTENTS

8
INTRODUCTION

12
PHOTOGRAPHIC FILM AND EQUIPMENT

16
SEEING THE LIGHT

18
GRAPHIC ELEMENTS

32
THE MICROCOSM

44
A SENSE OF PLACE

58
JUXTAPOSITIONS

72
SEASONAL THEMES

86
REITERATIONS

102
THE PASSING MOMENT

116
THE HUMAN TOUCH

126
THE WORLD AROUND US

144
INDEX

INTRODUCTION

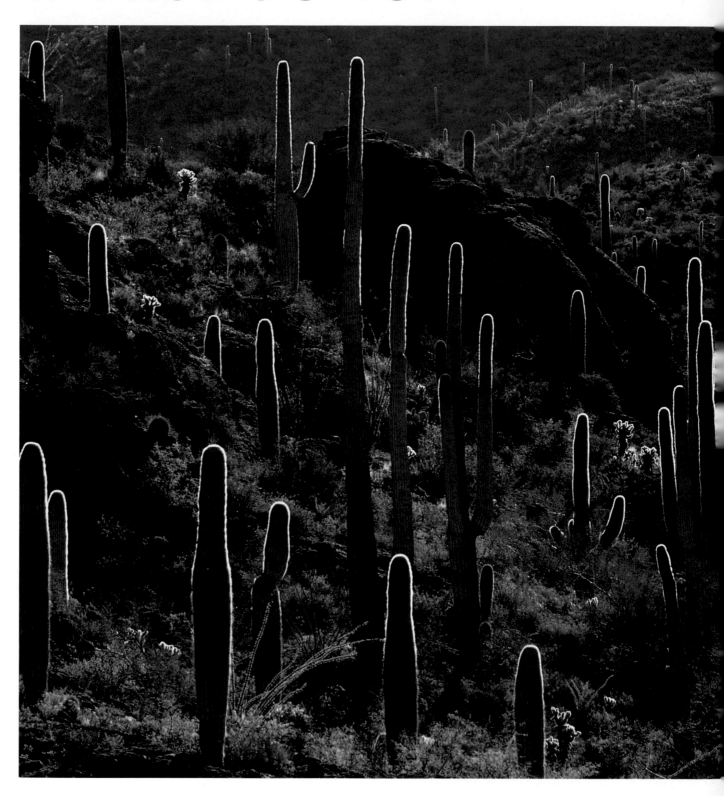

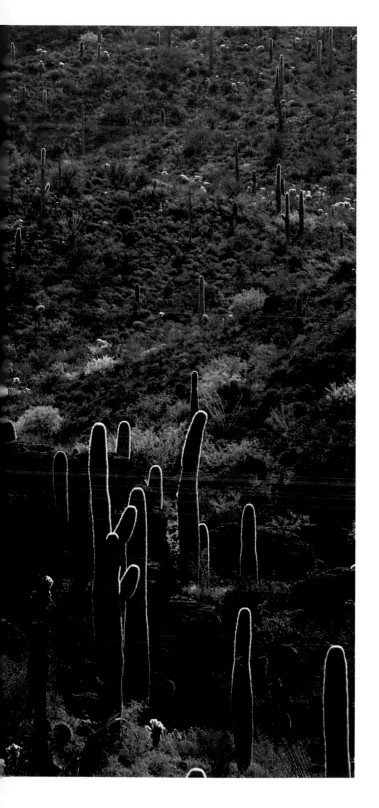

This book isn't about how to take a photograph. That is, it isn't about the mechanical step-by-step procedures you go through before you push the shutter button. This book is about the *process* of photography. It is about the process of control—the mental process of making decisions about exactly what to include in a photograph, exactly how to organize a photograph, and exactly what you want a photograph to be.

Photography is a way to order the chaos around you by emphasizing some aspects of the environment and ignoring others. You do this by choosing what to photograph and what to include in the frame. Then by using the tools of photography (lenses, films, light, and exposure) and by selecting a vantage point from which to photograph, you emphasize one aspect or another of your subject. In effect, you're telling the viewer what is important by your having made choices.

But order doesn't happen automatically. Simply pointing a camera at a subject doesn't guarantee a successful photograph if success is defined as an interesting, engaging work that involves the viewer's mind and emotions. You have to structure a photograph both technically and aesthetically without allowing these concerns to overwhelm the subject matter. When the construction of a photograph is more noticeable than its content, you've failed as a photographer; instead you are a dilettante in the worst sense of the word.

How to arrange a picture, how to make order out of chaos, should be a conscious decision on your part. Structuring your visual environment is the role of composition, and the more you can consciously control this structure, the better a photographer you'll be. I believe that far too often photographers—myself included—tend to be sloppy when it comes to making decisions. We slide by with such vague thoughts as "That's a pretty scene" or "Oh, I like that" without analyzing exactly what we mean. You should ask yourself some questions. What has influenced me? Why am I visually excited about a particular situation? What specifically can I do to emphasize the subject?

There is quite a difference between the procedure of photography and the process of photography, but a good work has both. Photography is a synthesis of two ways of dealing with the world, two ways of dealing with subject matter. On one hand, you must be a technician, determining shutter speeds and *f*-stops, choosing equipment, and mounting lenses, for example. You must have a rational, strictly scientific approach to your work. Here, step two must follow step one in the correct manner in order for the machinery to work properly to record an image. This side of photography is the logical world of procedure. On the other hand, you must also be a poet and an artist, paying attention to the intuitive and mystical world of your inner vision. You have to bring your own intense emotions about the subject to the photograph, otherwise it'll be lifeless. You must be able to see an image. This is the process of taking a picture.

Procedure without process is as much a failure as process without procedure. A photograph can't be successful without the interplay and mutual support of these aspects. Everyone has seen photographs that are technically immaculate but aesthetically insipid. The usual reaction to such pictures is that they are dull, uninspired work. Everyone has also seen photographs that are intensely personal and evocative yet lack a solid basis in technique. These are judged to be the result of bad craftsmanship and an inability to control the medium. The artist with his vision and the craftsman with his tools must unite to create a successful product.

The problem for most people, however, is that photographic procedures tend to confuse them. They get lost in technique, dealing with numbers and concepts that seem strange to them. For example, the *f*-stop series of numbers frustrates many people. I've seen otherwise competent people become completely helpless when faced with using a camera. I'm always amazed by people who say cameras are too involved to learn how to operate, yet these same people are lawyers, doctors, or accountants. A camera is no more a technical mystery than any other machine.

To be a good photographer, you *must* learn good technique. What prevents people from doing this is simply that they don't use their cameras very often.

Every time they pick up a camera, they must start over again at square one. As a result, they never get past the point of frustration. They never reach the point when technique becomes second nature to them, so they don't have to think about it. For example, can you state right now which direction you turn your lenses in order to focus them closer? How do you change the controls to set a slower shutter speed? Can you mount a lens onto your camera without looking at the camera? Ask yourself this even easier question: Where is your 24mm lens located in your camera bag? Can you grab it without searching through the entire bag? If technique is second nature to you, you should be able to answer these questions without any problem.

Buying an automatic camera isn't the answer to technical control. Setting a camera in the autoexposure and autofocus modes without thinking about what the camera is doing and knowing how to control it as needed, means abandoning your responsibility as a photographer. You give up making decisions and allow a machine that's only following programmed orders to make them for you.

Control of the technical side of photography frees you to concentrate your energy and drive on your vision. This is the main reason why I stress technique in my earlier books, *The Nature Photographer's Complete Guide to Professional Field Techniques* and *John Shaw's Closeups in Nature*. Technical skill is absolutely essential if you want to grow as a photographer. And control of the entire photographic undertaking is what you want to achieve. Technique shouldn't— indeed it can't—stand in your way if you ever want to be able to translate the pictures you see in your mind's eye onto film. Technique has to become automatic. You shouldn't have to stop to think about the procedures you're using while you concentrate on the image you want to capture. You must strive to achieve control of both process and procedure. You need to be able to master the two sides of photography so that you can produce the best pictures possible. As such, this book is meant to be read in conjunction with and as a companion to my other books. This book is about strategies for approaching the image itself and about expanding your control of the visual vocabulary.

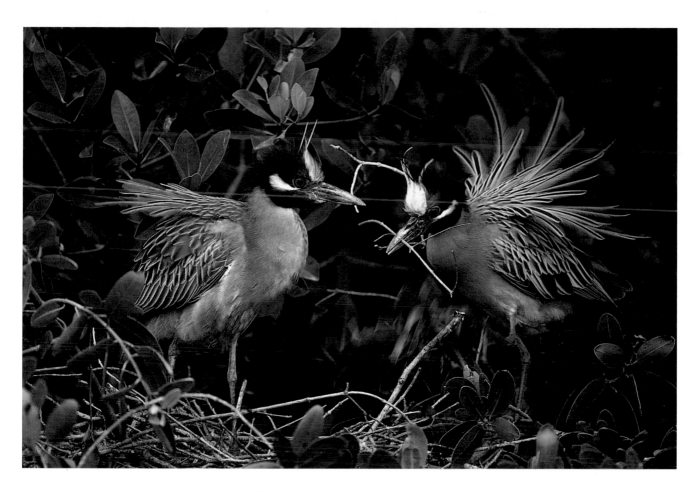

YELLOW-CROWNED NIGHT HERONS' COURTSHIP DISPLAY
Nikon F3, Nikon 300mm lens, Kodachrome 64

PHOTOGRAPHIC EQUIPMENT AND FILM

RED-PINE AND SUGAR-MAPLE TREES
Nikon F4, Nikon 50–135mm zoom lens, Fujichrome 50

ALL OF THE PHOTOGRAPHS in this book were taken with standard, off-the-shelf photographic equipment. I happen to own Nikon gear: F3 and F4 camera bodies and lenses ranging in length from 24mm to 500mm. I've been using Nikons since the late 1960s and am more than pleased with the line. But you certainly don't have to have a Nikon to take quality photographs. All currently produced 35mm cameras are equally good when it comes to recording an image on film. Too often, people look at my pictures and say, "Gee, you must have some good lenses." Indeed I do, but not once—regardless of how much I plead with them to do so—have my lenses gone out and taken a photograph. They just sit there in my office and wait for me.

Good equipment does, however, make working in the field easier. I suggest trying out different cameras at your local camera store in order to find one that has the features you want, feels good in your hands, fits your face when you look through it, and offers a system of lenses to back it up. I do own some very up-to-date camera bodies, but most of my lenses aren't the newest models. This isn't because the latest ones are in any way inferior; I just see no reason to replace a lens I already own with another one of the same focal length and speed.

Probably the most esoteric piece of equipment I use is an old, long-discontinued Nikon PB-4 bellows with an equally long-discontinued Nikkor 105mm short-mount, or bellows-only lens. Although I could use this outfit for closeup work, I don't. I have it because it offers swings on the front lensboard. Consequently, when I flop it over on its side, I end up with a tilting lens that enables me to change where the plane of focus falls. This plane doesn't necessarily have to be parallel with the film plane, as is the case with standard 35mm lenses. But this bellows/lens combination is bulky, slow to operate, awkward to carry, and has limited applications. I use it for probably less than 1 percent of my photography.

> ## NOT ONCE HAVE MY LENSES GONE OUT AND TAKEN A PHOTOGRAPH

The most important accessory I own (I hesitate to call it an accessory; perhaps "necessity" is a better word) is a sturdy tripod. Most tripods are far too flimsy, too short, and too poorly made. Over the last couple of years, I've concluded that if you are serious about your work and use lenses with focal lengths longer than 200mm, there is almost no such thing as a tripod that is too heavy. Currently, I use a Gitzo 320 tripod when I travel, and the bigger and heavier Gitzo 410R model when I work out of my car. In fact, I took every photograph in this book with my camera solidly mounted on one of them.

I sincerely believe that tripods are the most overlooked part of a camera system. Since 1988, I've been leading photography tours for the Joseph Van Os Photo Safari Company. I've seen many amateur photographers working in exotic locales, and the majority of them have inadequate tripods or have none at all. I'm continually amazed by people who either handhold the 1,500-dollar lens they bought because of its reputation for sharpness and quality, or at best mount it on a 25-dollar tripod.

Beginning photographers often believe that since their 35mm camera is fairly small, a small tripod is fine. They don't consider that as they progress to longer lenses, they're magnifying all problems as well as the picture image. For example, if a 50mm lens is your standard lens, then a 100mm lens is a 2-power optic. It will increase the effect of all vibrations, all missed-focus mistakes, and all defects by two. (This doesn't even take into account any closeup factors). And an 80-200mm zoom lens set at the long end is a 4-power lens. When you use it, you must keep the equipment four times as sturdy and be four times as careful in order to achieve the image quality obtained with your 50mm lens. Obviously then, when you use a 400mm or 500mm lens, a sturdy tripod is an absolute necessity. So buy a good tripod, and use it faithfully.

Unlike my ever-present tripods, I rarely use filters. And when I do add one, it is usually either a warming

or a polarizing filter. With Fuji Velvia film, I might use an 81A filter if I'm shooting in the shade with a large area of blue sky influencing the color balance or in overcast light. I almost never use a filter with the faster films because I shoot them only when I need as much speed as possible. I use a polarizer primarily to eliminate glare from vegetation and consequently to saturate its colors, and far less frequently to saturate the color of the sky.

One part of my photography that has changed since my last book is my film preference. Today I'm shooting three films. Until a few months ago, Fujichrome 50 was my stock film. Now Fuji Velvia is quickly becoming my standard film (although at this writing I've been using it for only about four months). Fujichrome 100 is my "fast-action" film. I wish it were a bit sharper, but the extra stop of speed over Velvia is worth the slight compromise when I need it; this is my bird-and-mammal-action film. Kodachrome 200 rounds out my film choices. I shoot it only in overcast light, and even then I use it sparingly. It is very sharp but very grainy. I choose it only when I really need the speed, although I often push Fuji 100 1 stop (to an effective film speed of ISO 200) to produce the same results. The colors of the films differ slightly: the Fuji film is warmer and more saturated than the Kodachrome. My intended subject matter usually dictates my decision. I estimate that I shoot about 75 percent ISO 50 film, 20 percent ISO 100 film, and 5 percent ISO 200 film.

As you read this book, you'll discover that I used a view camera for some of the pictures. I haven't in any way forsaken my 35mm equipment. Indeed, my pro-

BUY A GOOD TRIPOD, AND USE IT FAITHFULLY

fessional career has been built around my Nikons and the flexibility of the small-format camera. But view cameras, in my opinion, have two major advantages. First of all, they slow you down. Compared to 35mm cameras, they are very slow to operate—even under the best conditions. But this makes you a more methodical and careful worker. Knowing that you can't shoot dozens of variations of a picture teaches you to be discerning, selective, and deliberate.

Second and I think more important, view cameras tend to change the way you compose a picture. The image on a view camera's ground-glass is upside down and backward. This denies you the easy recognition and identification of your subject matter; instead, you have to deal with it in graphic terms. For example, when I look at a tree through my 35mm camera, I see a familiar object in the viewfinder. This isn't quite the case with a view camera. Here, I don't see a tree on the groundglass, just line and form. This disorientation of perception changes the way I compose, for the better I believe. You can experience this by looking through your 35mm camera upside down and taking a photograph.

My view camera isn't a 4 x 5 camera but rather an actual medium-format rollfilm model. I have a Horseman 985, which is essentially a baby 4 x 5 that hasn't grown up yet. It gives me 6 x 7cm images on 120 size film. I have three Schneider lenses for my view camera: a 65mm lens, a 100mm lens, and a 150mm lens. (The equivalents for a 35mm camera are a 32mm lens, a 50mm lens, and a 75mm lens.) Although I rarely use my view camera, I do try to incorporate what I've learned with it into my 35mm work.

BLACK-EYED SUSANS, DAY LILIES, AND FLEABANE
Nikon F4, Nikon 35mm lens, Fujichrome 50

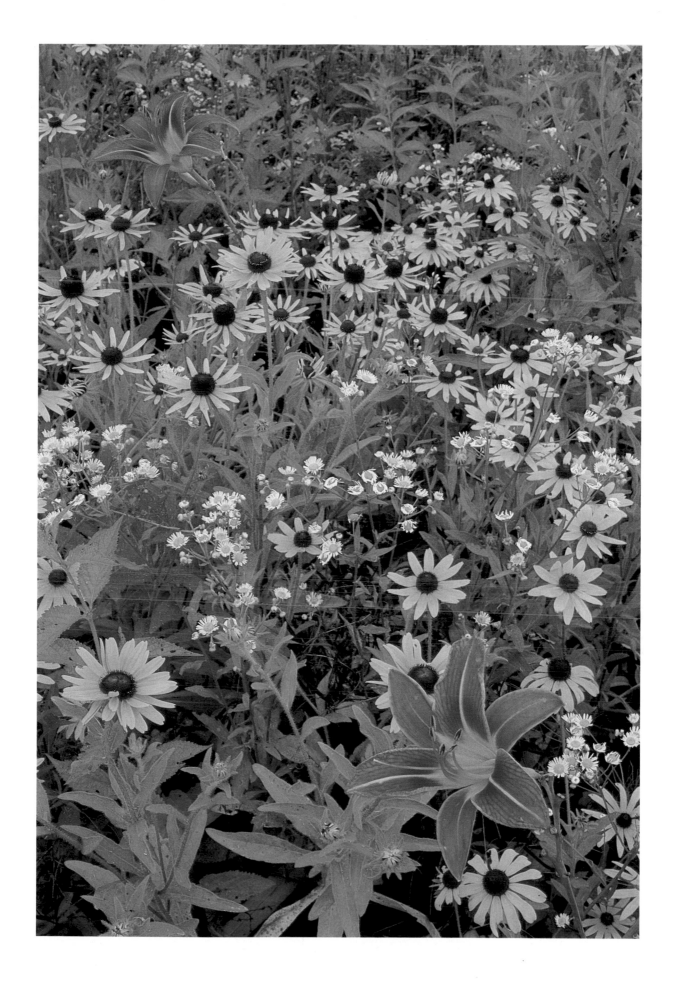

SEEING
THE LIGHT

SUNRISE OVER GREAT SMOKY MOUNTAINS
Nikon F3, Nikon 50–135mm zoom lens, Fujichrome 50

MOST PEOPLE DON'T SEE the nuances of light on the landscape. A photograph is only a two-dimensional representation of our experience. The fuller the experience, the more it touches all of our senses, the better our photographs are. Visual sensitivity to the landscape and how it is shaped by light is a skill that we need to develop. We must learn to spontaneously respond to unexpected moments of clarity and light. We literally must have insight.

Many of us never actually see the light. I believe this happens because we are in such a hurry that we don't have the time to watch how the light changes and consequently alters the appearance of subjects. Without noticing change, we see neither the beginning nor the end but think that how subjects look at the observed moment is how they always look. I once saw a man pull into an overlook at the Grand Canyon in the middle of the day. He got out of his car, took a snapshot, and then turned to his wife and said, "Well, we've done the Grand Canyon. Let's go." And off they drove. He could've stayed in that exact spot for the rest of his life and never have "done" the Grand Canyon. The man had recorded just a single moment in time, with one camera, one lens, one film, and from one vantage point. He could've photographed that vista forever and never have taken the same picture twice because the light is continually changing.

We all tend to do this, consciously or not. I am as guilty of being in a hurry as everyone else. When I travel to a new location, I often feel I must get a

> ## SLOW DOWN, STAY A LITTLE LONGER, JUST WAIT AND WATCH

definitive photograph immediately. The pressure I place on myself to produce prevents me from seeing what is happening around me. Like most other people, I need to slow down. Keep in mind that our perception of a place is colored by the time of day and year that we saw it. For example, if you visit the Everglades on a morning in February, the way it looks at that particular time is the way it will be locked into your memory. But the Everglades in February isn't the Everglades in July, and the Everglades in the morning isn't the Everglades at twilight.

I realize that most of us are pressed for time to photograph. We have appointments to keep, jobs to go to, and engagements that take up our time. But learning to see the light, to see how light changes a subject during a day or a season's duration, is of utmost importance. The word "photography" literally means to paint with light. An awareness of light is our first and most essential tool in terms of our aesthetic control when taking a photograph.

A good exercise is to watch how the light changes the appearance of a subject during the course of a day. Select any subject, such as your house, a nearby field, or an isolated tree, and photograph it every hour from before dawn until twilight. Use the same lens, film, and framing. Then study the resulting photographs to discover what the changing light did to your subject.

Slow down, stay a little longer, just wait and watch. Only by being in the field and observing the light play upon the landscape can you truly learn to see the world around you.

GRAPHIC ELEMENTS

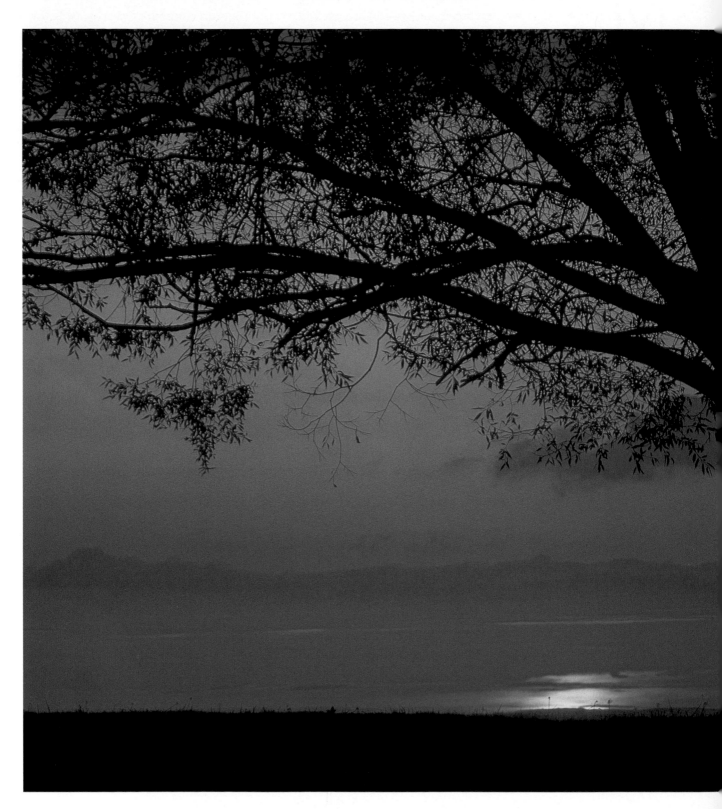

WILLOW TREE AND AUTUMN SUNRISE
Nikon F3, Nikon 200mm lens, Fujichrome 50

IN PHOTOGRAPHY, THAT IS,
PHOTO-GRAPHICS, YOU'RE
DEALING WITH THE GRAPHIC
ELEMENTS THAT ARE
COMMON TO ALL VISUAL
ARTS. YOU MUST BE
CONSCIOUS OF THE BASIC
BUILDING BLOCKS OF
DESIGN: COLOR, LINE,
PATTERN, TEXTURE, AND
FORM. THESE BECOME YOUR
VISUAL VOCABULARY, AND
PHOTOGRAPHIC TECHNIQUE
PROVIDES THE SYNTAX. THE
SYNTHESIS OF THE TWO IS
COMMUNICATION.

The Arizona-Sonoran Desert Museum has a wonderful native-plants garden. I was demonstrating some closeup techniques to a workshop group at the museum when I saw backlighting coming through the very edge of an agave. I tried to use my 105mm macro lens, but its focal length wasn't long enough. I needed to shoot almost wide open with minimum depth of field in order to isolate this one strip of color and to avoid bringing the background into focus. The agave was a large plant with very stiff leaves, and I couldn't get my tripod into position using my 105mm lens; the tripod legs had to go where the plant was, and the sharply pointed leaves were extremely close to my face.

To gain some working distance, I quickly replaced the 105mm macro lens with an 80–200mm zoom lens and added a Nikon 4T closeup lens. This combination yields a final magnification, by close-focusing the lens, of about life-size on film, filling the frame with a subject 1 x 1½ inches in size. It then took me several minutes to position my tripod. Several times I glanced through my lens, minutely shifted location, and checked the tripod's placement. In the end, I was lying spread-eagled on my belly, my face against the ground, looking up through my viewfinder. By this time, the light that had attracted me in the first place was quickly fading. I managed to get off three frames before the light was gone.

EDGE OF AN AGAVE LEAF
Nikon F4, Nikon 80–200mm zoom lens, Nikon 4T closeup lens, Fujichrome 50

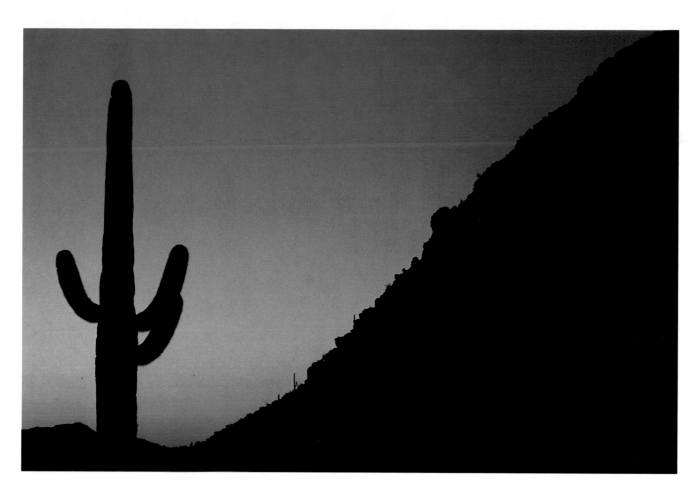

SAGUARO CACTUS
SILHOUETTED AT DAWN
Nikon F4, Nikon 80–200mm zoom lens,
Fujichrome 50

On the road over Gates Pass, just west of Tucson, Arizona, is Tucson Mountain Park, a great place to photograph the sunrise in the Sonoran desert. The park is easy to get to, while Tucson remains neatly hidden in the valley below. You need to arrive at least an hour before sunrise in order to have enough time to scout out the area and discover your photograph.

I was fascinated by the silhouetted shapes formed by the giant saguaro cacti against the dawn sky. Finding the exact one to photograph, however, wasn't an easy task. I hiked quickly from one cactus to the next for about 15 minutes, searching and scrutinizing before coming across one that I could isolate against the sky. I metered the dawn sky first and then the ridge to the right. Since these readings were about 6 stops apart, I knew that if I placed the sky as a light color (1 stop open from my meter reading), the ridge would fall as a pure black silhouette lacking detail. I wanted to balance the frame by cutting it in half with the hillside.

This is an example of the use of negative space. Even though the hill is simply a black area in the frame and shows no detail, it is vitally important to the composition. While there is "nothing" there, this "nothing" is absolutely necessary because it anchors the light sky and stabilizes the cactus. If I had omitted this area, the composition would fall flat. Notice that the line formed by the hill divides the frame but doesn't come directly out of either corner. It is much better to set strong lines away from the exact corner of the frame.

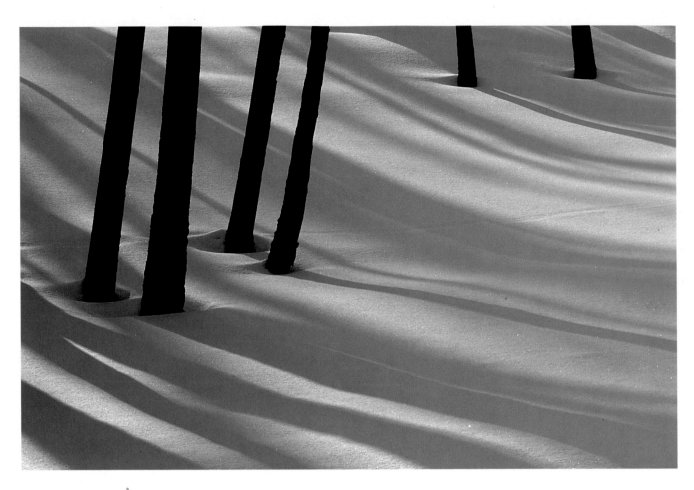

BURNED LODGEPOLE PINE TRUNKS
Nikon F4, Nikon 50–135mm zoom lens,
Fujichrome 50

In Yellowstone National Park, the road from Mammoth to Cooke City passes through an area of burned lodgepole pines immediately before it turns at Tower Junction. In February, the midday sun just manages to crest the hill, causing shadows to cascade down toward the road.

One winter, when I led a photo tour of Yellowstone, I drove through this location several times. I was struck by the possibilities of the graphic elements: black burned trunks, white snow, and blue shadows. I realized that I needed to be there at the right time on a sunny day so that the shadows would be at their longest and deepest. Then it was just a matter of finding the right composition. Since the shadows were always changing, I had to work fast. I ran back and forth along the road, looking through my handheld camera, searching for a spot that seemed to offer the best potential. I used a zoom lens in order to crop the framing without my having to move closer to or farther away from the subject. Consequently I didn't have to wade into the snow, which was about 3 feet deep; I was able to set up my tripod and shoot from the shoulder of the road.

I tried several different compositions, but I like this one best. The limited number of black trunks doesn't overpower the more open shadow/highlight pattern. If I'd pointed my camera any higher, I would've included several more tree trunks; any lower, and I would've eliminated the two in the upper right that offer a counterpoint in number, size, and direction to the four trunks on the left. This composition, however, enabled me to emphasize the long shadows falling diagonally across the frame.

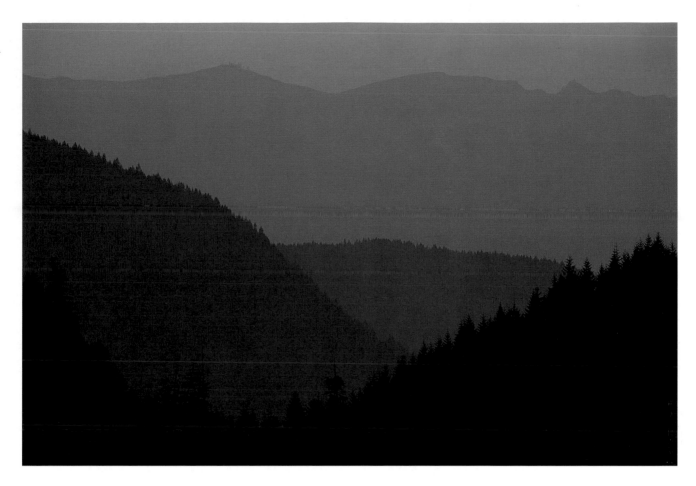

STACKED MOUNTAINS AT TWILIGHT
Nikon F3, Nikon 200mm lens, Fujichrome 50

I photographed this scene in the Mt. Shuksan area of North Cascades National Park, Washington. Alternating periods of rain and sunshine gave me a wide range of subjects to work with, from raindrops on grasses to mountain scenics with billowing clouds. I had to get back to Seattle that night and I was facing heavy traffic on the interstate, but I delayed packing until the last possible moment.

As I turned a corner, I saw through an opening in the trees these mountain ridges stacked into the distance and bathed in the early-evening light. The light was changing rapidly, and I had a choice to make. Should I find a place where I could turn around on the narrow mountain road, backtrack to the spot I had seen, get my car off the road somewhere, and photograph, or should I head back to Seattle? After all, I'd had a good day of shooting and knew that I already had some quality images on film. I decided to continue driving, but I kept thinking about the stacked ridges. Every time I came to an opening where I could see the sky, I slowed down and scanned it. I noticed that more color was developing. Finally, I stopped. I realized that I had to make a definite decision: to photograph or to drive. So I went back to my first spot.

I set up my tripod only a few yards off the highway just as the color of the sky deepened. What impressed me were the ridges in front of one another, so I knew that I would need a fairly long focal-length lens. This would enable me to pull out one narrow section of the mountains and make use of telephoto compression. I picked up my 300mm lens first, but when I scanned the horizon while handholding the camera I discovered that its focal length was too long. I then replaced it with my 200mm lens and quickly found a section of the mountains that I liked. I mounted the camera on my tripod, metered the sky, opened up 1½ stops to place it as a light color, and took a series of shots.

As I thought about leaving, I realized that the light was getting better. So I relaxed and watched the sky. Five minutes later, it was a soft magenta. I continued to shoot, once again opening up 1½ stops above my meter reading of the sky. In fact, I stayed in that location until dark. The light show didn't go on all that time; after appearing magenta, the sky changed to gray and just darkened. But because I'd stopped to photograph, I could allow myself to enjoy the evening. I saw the light.

TUNDRA IN AUTUMN, BEARBERRY, AND LOW-BUSH CRANBERRY
Nikon F3, Nikon 55mm lens, Fujichrome 50

I love the fall, filled as it is with color as crisp as the weather. While autumn in Michigan means shooting sugar maples in October woodlots, autumn in Alaska's Denali National Park comes at the end of August and calls for looking down by my feet. On the tundra, fall color is only a few inches high, so it is time for closeups.

Alpine bearberry turns the brightest red of any plant I know. Because it is common vegetation in Denali, sometimes expanses of it color the ground for quite a distance. At other times, just a few leaves can be found. What I wanted to photograph most of all was the contrast between the red bearberry leaves at peak color and a rich green background. I was staying in Denali for several weeks, so I was able to watch the bearberry color intensify and wait for the ideal moment. I searched until I found a perfect situation; however, I didn't have the perfect equipment. I went to Denali primarily to photograph mammals and birds, not closeups. With this size subject, I would normally use my 105mm macro lens but I didn't have it with me. My only choice was my old 55mm macro lens. Using it meant that I had little working distance, and consequently maneuvering my tripod into the exact position was frustratingly awkward. At least the weather cooperated: Alaska's notorious overcast sky provided open, even light that was perfect for this design.

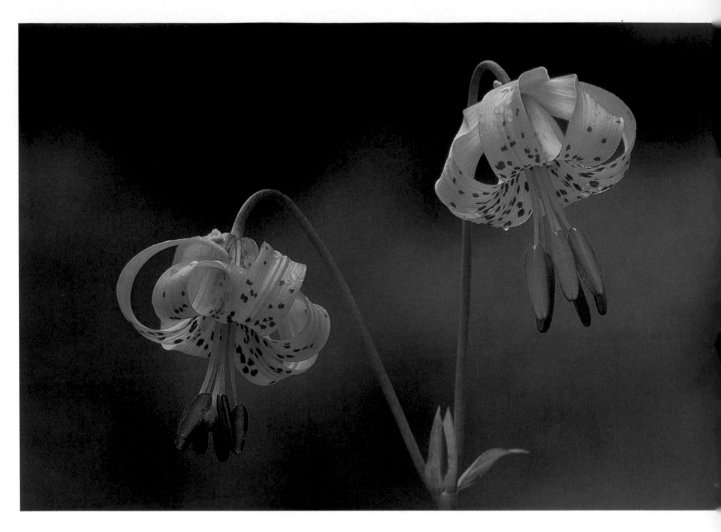

COLUMBIA LILIES
Nikon F4, Nikon 200mm macro lens,
Fujichrome 50

I was photographing in Olympic National Park when I found these Columbia lilies early one wet morning. They were in perfect condition. Their petals were curved tightly and their stamens covered with pollen, and as of yet, they hadn't been ravaged by insects or the weather. I wanted to isolate the two blossoms against the uniform green background, provided by trees about 20 feet away, and at the same time to shoot slightly up at the blossoms in order to see into them. I chose my 200mm macro lens although any lens of this focal length or longer would've worked just as well. I simply needed a focal length long enough to enable me to narrow the background coverage and to exclude the sky.

A slight breeze persisted in annoying me as it caused the blossoms to sway. I poked a dead stick into the ground, angling it so that it gently touched the flower stalk just outside the picture frame. This cut down on some of the worst movement. Next, I used the depth-of-field preview button to determine which *f*-stop would provide just enough depth of field. I wanted to cover the flowers, but I didn't want the background in focus. I metered the blossoms and the background and discovered that they were exactly 1 stop apart. I placed the blossoms as a medium orange and let the green background fall one stop darker. Finally, I framed the picture very carefully. I wanted to include not only the two blossoms in opposite corners but also the junction of their stems as well as the small leaves at that point. Then it was just a matter of waiting for a perfectly calm moment.

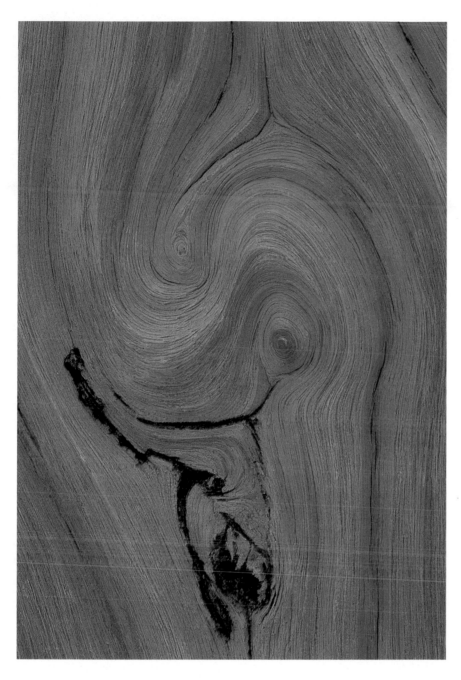

BRISTLECONE PINE WOOD PATTERN
Nikon F4, Nikon 200mm macro lens, Fuji Velvia

The Mount Goliath Natural Area, on the road to the summit of Mt. Evans near Idaho Springs, Colorado, is one of the easiest places to get to bristlecone pines. They are some of the oldest living trees on earth; those in this area, for example, are between 1,500 and 2,000 years old. The trees found at timberline often have no bark on the upwind side, which is polished bare by wind-driven snow. I love these pines both for their tenacious hold on life and for their beautiful convoluted forms.

I spent several hours shooting scenes with entire trees but slowly kept focusing tighter and tighter. The patterns in the bare wood grain were fantastic. This particular swirl of wood is about 2 x 3 inches; in other words, I was photographing at half-life-size, the near focusing limit of my 200mm macro lens. I used this lens simply because it was the one I had with me. I could've easily shot with my 105mm macro lens or any combination of tubes or closeup lenses, but that would've entailed hiking back to my car. The 200mm focal length afforded me a considerable working distance between the lens and the tree trunk, making it quite easy for me to position my tripod with the camera perfectly parallel to the wood. Consequently, I didn't have to stop down for increased depth of field; a medium *f*-stop was fine. I metered the wood itself and then opened up 1 stop (actually by slowing the shutter speed 1 stop) so that the wood appears the same amber color in the slide as it was in reality. If I'd shot at my meter reading, the wood would've come out too dark on film, appearing as a medium-toned value.

I was out at first light one October morning in north-central Michigan. As I headed toward a favorite woodlot, thinking about looking for fallen leaves rimmed with frost, I caught a glimpse of a sumac patch at peak color partially hidden behind a row of trees. Sometimes I find it difficult to stop and explore a subject when I have a preconceived notion as to what I'm going to do. After a lengthy debate, I turned my truck around and went back to the sumac. I hiked into the field only to discover an intensely red sumac thicket, a far better subject than my first glance suggested.

The problem I faced was deciding how to order the photograph. Most of the sumac was jumbled together. I couldn't back away and shoot a large section without including the sky in the frame. And I knew that at this time of day, the sky would record on film as a washed-out, whitish-gray color. My only solution would be to aim a lens down on the sumac and eliminate the sky. Not having a ladder or anything else to stand on, I could only shoot down and still encompass a large area by using my widest-angle lens, a 24mm. Then it was simply a matter of finding the right subject. I searched around for about 5 minutes before I saw this curving line of saplings leading to the main sumac patch. I ended up working with my camera as high as I could get it; in fact, I had to stand on tiptoe to see through the viewfinder. If I'd shot from any lower camera position, the individual sumacs would've merged, not stood out against the golden grass.

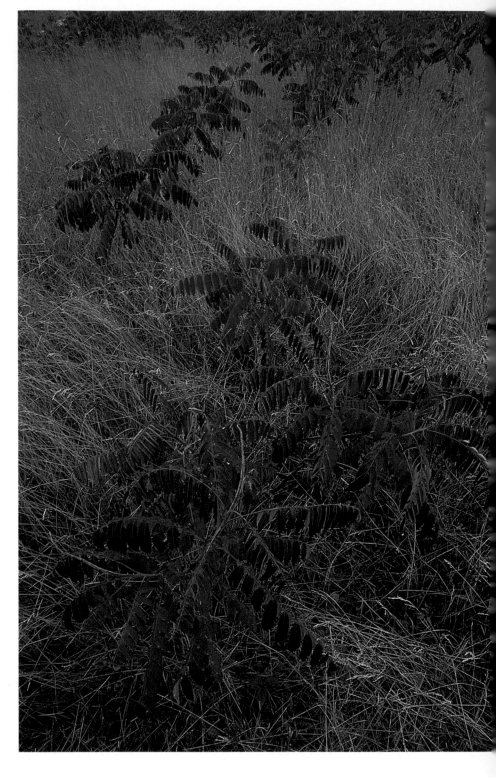

STAGHORN SUMAC IN AUTUMN FIELD
Nikon F4, Nikon 24mm lens, Fujichrome 50

CRESTED DWARF IRIS
Nikon F4, Nikon 105mm macro lens,
Fujichrome 50

The crested dwarf iris is found throughout the southern Appalachians. Growing in patches, its blooming signifies the peak of the spring wildflower display, before the canopy of leaves overhead brings this beautiful time to an end. I was in Great Smoky Mountains National Park working on general spring coverage and watching for a good iris specimen. All of the ones I found weren't quite right: a group that was too old and tattered, a single blossom that was too pale in color. I'd stopped to photograph a mountain scene when, while putting my equipment back into my truck, I noticed a small patch of irises on the other side of the road. At last here was my flower, only 2 feet from the pavement.

The major problem I faced was oncoming traffic. I set my tripod at the very edge of the road and used the shortest focal length I could that gave me the framing I wanted. In between cars blasting past me, I carefully composed a vertical picture using the iris leaves as leading lines pointing to the blossom. One true challenge of nature photography is depicting a subject as serenely pristine when in reality it is trembling in a slipstream.

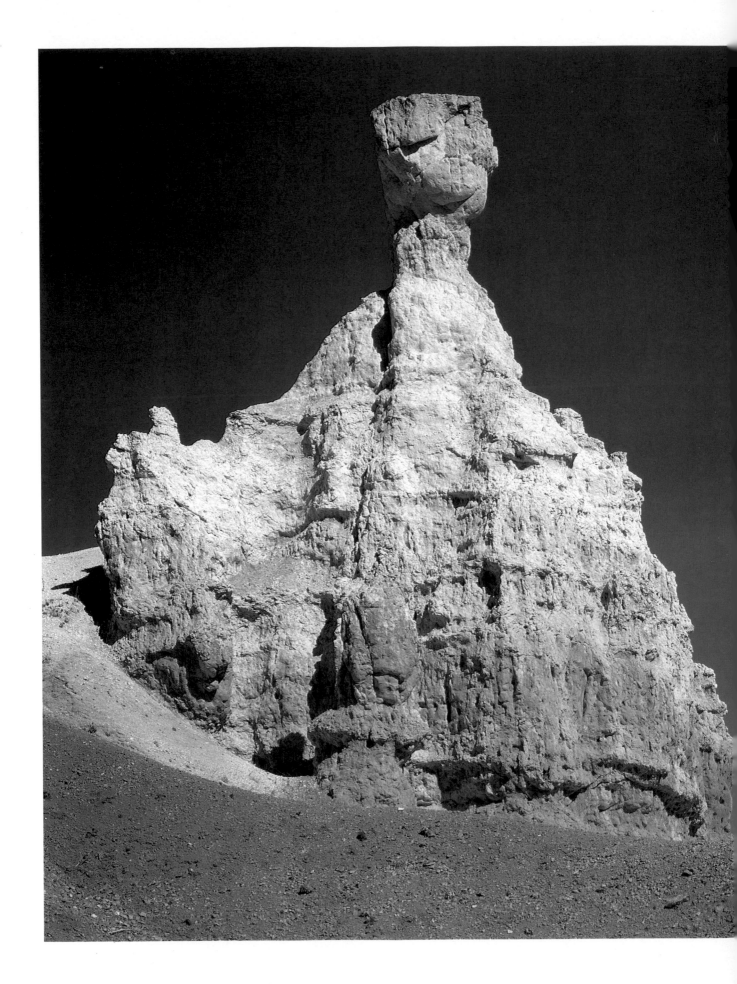

This is an unusual photograph for me to take. I rarely like to shoot scenics on pure-blue-sky days, especially during the flat light of midday. I was in Bryce Canyon National Park in April, hiking along trails that still had snowdrifts in some shadowed spots. While scouting the area called the Queen's Garden, I happened across this scene. I was struck by all the contrasts in front of me: between the highly textured rock and the featureless sky, between the mass of the formation and the small, delicate curve of the dead tree, and between the elemental colors of brown, white, and blue. Luckily, the midday sun isn't directly overhead in April so the formation had some directional sidelighting instead of unflattering toplighting.

The problem I faced was hiding a well-used trail that runs past the left side of the eroded rock. By backing away, I was able to utilize the foreground ridge as a screen. But I had to be careful not to completely cut off the base of the formation. I didn't want to lose the curve of the white area on the extreme left entirely. Once I found the correct camera angle, it was simply a matter of moving a little closer or farther away to adjust the framing for the lens I was using. Adding a polarizing filter saturated the colors and eliminated the harsh glare off the rock.

THE QUEEN'S GARDEN
Horseman 985, Schneider 150mm lens, Fujichrome 50

THE MICROCOSM

WORLDS WITHIN WORLDS. CLOSEUP PHOTOGRAPHY ENABLES YOU TO JOURNEY GREAT DISTANCES, YET AT THE SAME TIME SEE THE PERFECTION OF THE COMMONPLACE AND DISCOVER LIFE'S UNDERLYING HARMONY AND ORDER SEEING THE SMALLEST DEWDROP, YOU CAN STAND IN AWE OF PERFECTION.

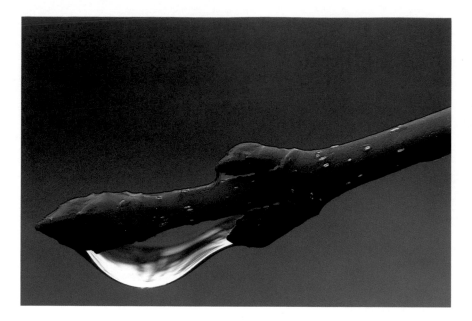

RAINDROP ON MAPLE BUD
*Nikon F3, Nikon 105mm macro lens, Nikon 4T closeup lens,
Nikon 52.5mm extension tube, Fujichrome 50*

It is a rare day indeed that offers the combination of factors needed for this photograph: a gently saturating rain followed by absolute dead calm. But that is exactly what happened one wonderful midwinter afternoon, completely transforming my backyard. Huge drops hung from every branch in a breathtaking display.

I took this shot using a combination of equipment. I wanted to fill the frame by zeroing in on the bud and raindrop, which entailed a magnification rate of about 1½ times life-size. I could've used extension tubes alone to reach this, but instead by adding the closeup lens I gained a little more light in exchange for slightly shortening the focal length. I mounted the whole lens/extension tube combination on a focusing rail so that I could move it closer or farther from the subject in order to fine focus. The hardest part of taking this photograph was getting the tripod into position. I had about 3 inches of free clearance between the end of the lenshood and the droplet. The slightest mistake and I would've ended up with a wet lens and only half a subject. Finding the perfect raindrop and then positioning the tripod took me about 15 minutes.

By composing with the droplet in the bottom of the picture, I emphasized the implied action. You know that the drop is going to fall, and its location in the picture subtly reinforces this. The drop's weight and size are already pulling it out of the frame.

HORSETAIL WITH LADY FERN
Nikon F3, Nikon 35mm lens, Fujichrome 50

34

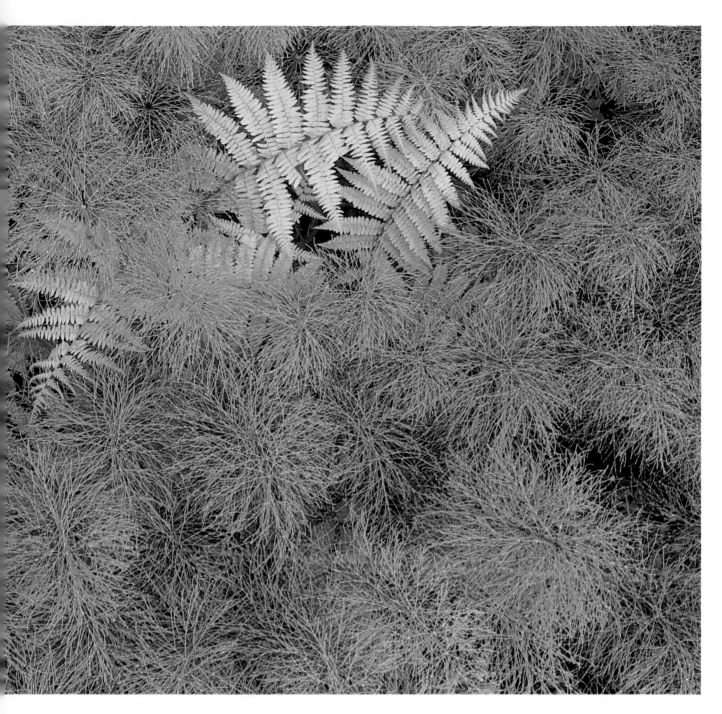

I'm always quietly elated when I discover layers of feeling within a subject, finding contrasts that are hidden from those who only glance. Such was the case when I found these lady ferns buried deep in filmy horsetail. I couldn't see the small fern fronds from a distance; they were visible only when I was right on top of them, literally looking straight down. There was just one place to photograph from; I had to shoot with the camera positioned directly above the ferns. Although this is a fairly intimate picture, the covered area is several feet square. I needed coverage, but I couldn't back

up. Perhaps I should say I couldn't *raise* up since there was no easy way to stand above the ferns and look down.

My only solution to achieve the necessary coverage at such a close working distance was to use a short lens aimed down. But then my feet, as well as the tripod legs, intruded into the picture frame. I extended all three tripod legs as far as possible and spread them wide apart. Then I leaned into my camera, carefully supporting my weight so that I didn't tip into the horsetail. This wasn't an easy or very graceful exercise, but the results were well worth it.

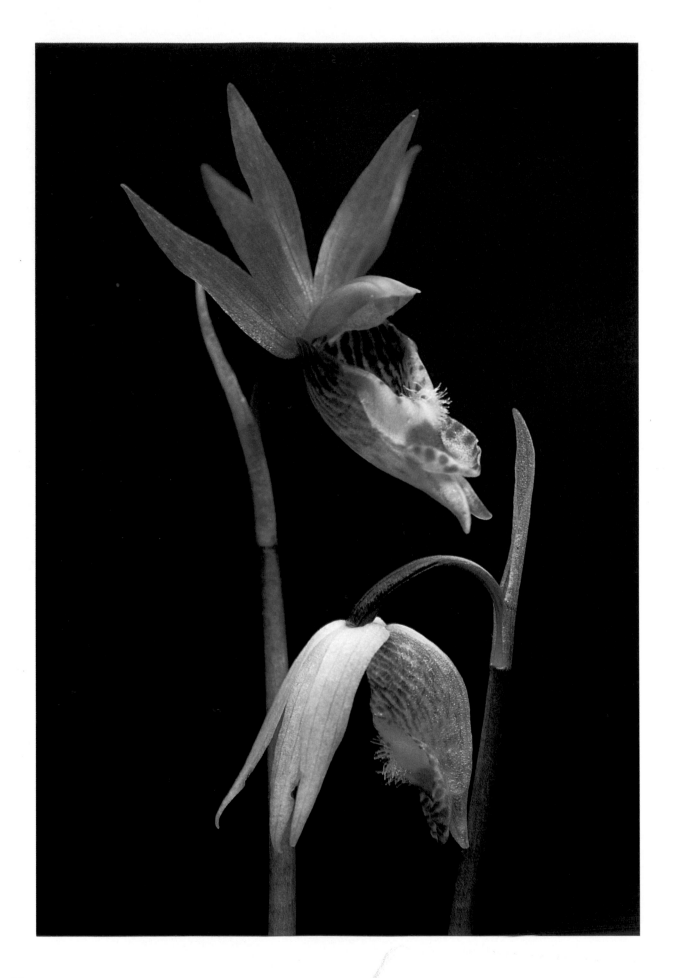

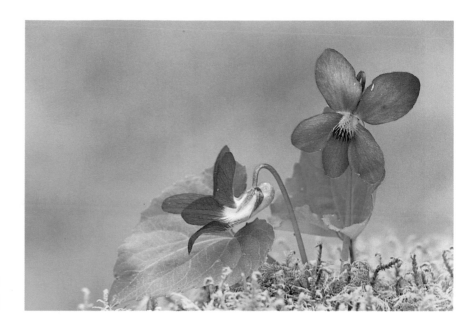

MARSH BLUE VIOLETS
Nikon F4, Nikon 200mm macro lens,
Fujichrome 50

I found these violets growing in an odd place: amidst the moss on top of a fallen log. I was photographing spring flora in the Tremont area of Great Smoky Mountains National Park in mid-April and came upon these flowers by accident. The moss in which they were growing was covered with old hemlock needles and other debris. I spent some time carefully removing each little piece of organic litter. Once the scene was clear, I set up my camera and tripod and composed. I wanted to use a polarizer in order to eliminate some of the sheen from the leaves, but the low light level made me afraid to slow my shutter speed any further. A gentle breeze kept swirling through the area. I managed to shoot about six frames between gusts, not sure if any would be sharp, before rain forced me to give up. I planned to return when the rain stopped, but the violets were badly beaten down by that point.

CALYPSO ORCHIDS
Nikon F4, Nikon 200mm macro lens, Fujichrome 50

These calypso orchids were growing in a mossy old growth area of Willamette National Forest. They are quite small; each blossom is only about 2 inches long, and the whole plant is no more than 6 inches tall. In order to photograph these orchids, I had to spread my Gitzo tripod as low as it could possibly go. Because I wanted to isolate the two flowers against a poster-like background, I used a long-focal-length lens, my 200mm macro, to narrow down the background coverage. This longer lens also enabled me to back off and shoot more parallel to the ground. I positioned the camera very carefully so that the downward thrust of the top blossom falls into a "vee" formed by the lower plant's stem. Then I waited for the breeze to die down.

Discovering these small orchids was a particular delight. Here, in this forest of immense trees, I suddenly saw these delicate orchids, quietly celebrating the ancient woods. I find this to be a serenely quiet photograph, but there is a feeling of expectancy since the bottom flower isn't fully opened yet.

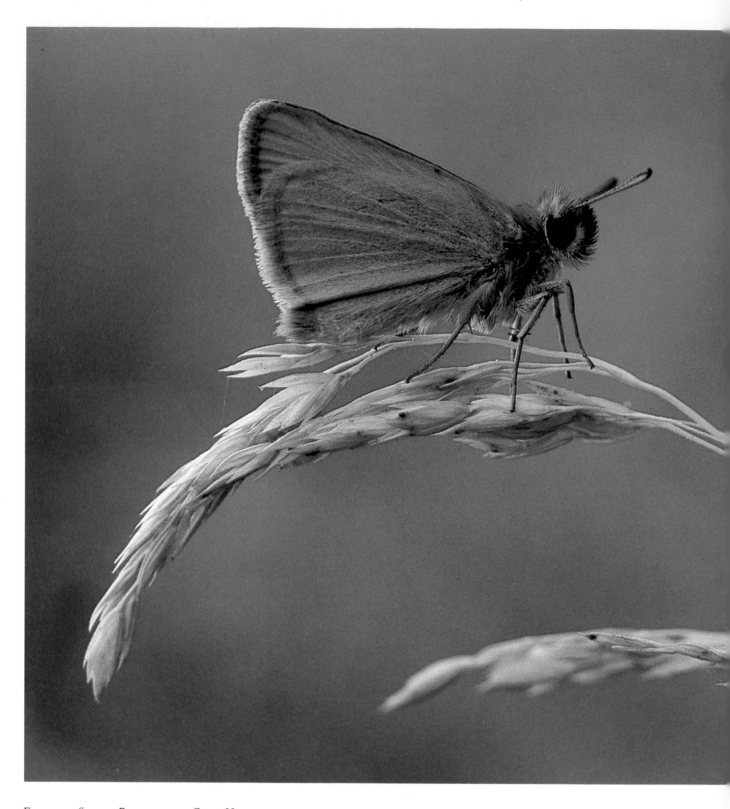

EUROPEAN SKIPPER BUTTERFLY ON GRASS HEAD
Nikon F3, Nikon 105mm macro lens, Fujichrome 50

I discovered this European skipper butterfly very early one midsummer morning. I was exploring the roadsides along an old corduroy road that runs through several miles of wet, swampy woods, which is a great place to find spider webs, ferns, flowers, and insects. A heavy cedar/tamarack forest on either side of the road blocks light and wind for several hours after sunrise, and is a boon to early-morning photographers.

When I found this specimen, I was impressed with the way it was sitting at the very top of the curved grass head. I knew that in order to maximize the little depth of field I would have at this image size (about half life-size on the film), I needed to position my camera so that the film plane would be exactly parallel to the butterfly. This was easier said than done. The skipper was sitting in the midst of an area of dense, interleaved sedges and grasses. I had to ease the tripod legs into position one at a time to make sure that I didn't accidentally knock the butterfly off its perch. I used a 105mm macro lens and mounted my camera on a focusing rail. It was hard enough getting my tripod even close to being in the right position without trying to reposition it precisely. The focusing rail solved that problem neatly and easily.

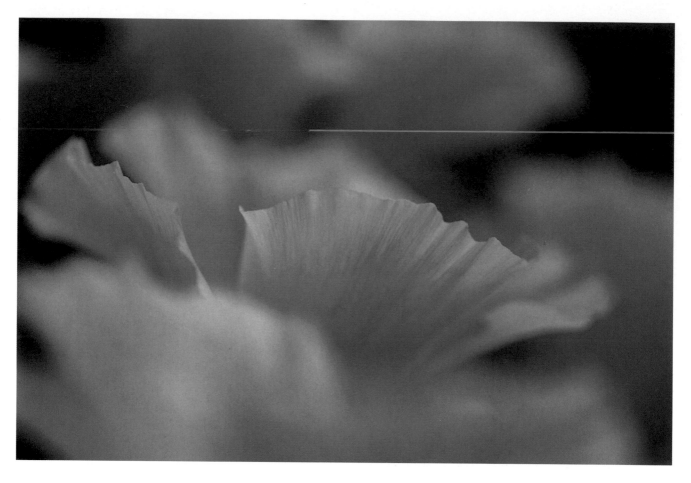

CALIFORNIA POPPY
Nikon F4, Nikon 200mm macro lens,
Fujichrome 50

This isn't typical of me. I consider soft-focus photographs all too often to be trite and sentimental. But this idea got me thinking about prejudging images. Everyone falls into fixed ways of thinking and working because it is always easier not to change. Routines are repeated over and over because they are familiar.

When I discovered an area thick with California poppies in full bloom, I took a number of pictures of the entire expanse using my 24mm lens. I emphasized the foreground by having the closest flowers about a foot from the lens. I was actually sitting on the ground beside my tripod, right next to the poppies, feeling slightly despondent at having done the same old thing. That is when I considered shooting through them with a long lens. I picked up my 200mm macro lens, left the aperture wide open, and scanned nearby areas. By working fairly close, I was able to limit depth of field, emphasizing only one plane of focus. I swung the lens back and forth to change focus and framing until I zeroed in on this flower. Then I metered and opened up half a stop to place the yellow a little lighter than medium.

You should intentionally try to break out of your photographic ruts. Once you've taken a picture the way you normally work, pick up the lens you would least likely use, and find another photograph.

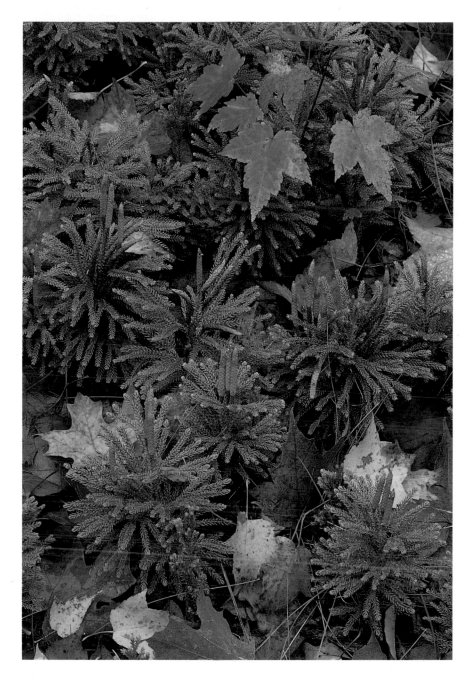

TREE CLUB MOSS
Nikon F3, Nikon 105mm short-mount lens on
PB-4 bellows, Fujichrome 50

Tree club moss are a throwback to another time. Their fossil history dates back to the Paleozoic era, which took place more than 300 million years ago. At that time they were tree-sized, and their compressed bulk contributed to what is now mined as coal. Today's species are far smaller, but no less interesting.

I particularly liked this group, surrounded by autumn leaves and a tiny red-maple seedling. I wanted to photograph the moss at an angle because people usually look down at an object on the ground in front of them. I wanted overall sharpness, but this would be impossible to get at this image size simply by stopping down. My solution was to use my old PB-4 bellows, which allows me to make use of its tilting lensboard. By tipping the front standard slightly forward, I was able to change the plane of focus from being parallel to the film to becoming that of the plane of the plants. This technique is known as the *Scheimpflug principle* and is often used by view-camera photographers.

I had been out one January day looking for pictures with no success at all. It was a typically dull, damp, overcast Michigan winter day; you couldn't tell where the earth ended and the sky began. I'd given up and was hiking back to my truck, cold and depressed. As I carefully crossed a small stream, worried more about the ice breaking than finding images, I looked down and was amazed. In one small section, the stream had frozen and refrozen, creating many layers of ice and trapping air bubbles deep within them. This sight quickly changed my mood.

I didn't want to fool around with equipment in the cold. I just wanted to use the simplest way possible, so I added a closeup lens to my 80–200mm zoom lens. This enabled me to crop the frame by zooming in and out, which was easy to do even with gloved hands. Handholding the camera, I searched for the exact space I wanted and tried different compositions. Then I carefully positioned my tripod directly over the best design. I found myself wishing I had my motor drive attached to my Nikon F3 camera. Every time I cocked the shutter, the tripod slid a fraction on the ice, just enough to force me to recompose. Consequently, no two frames from that film are exactly alike.

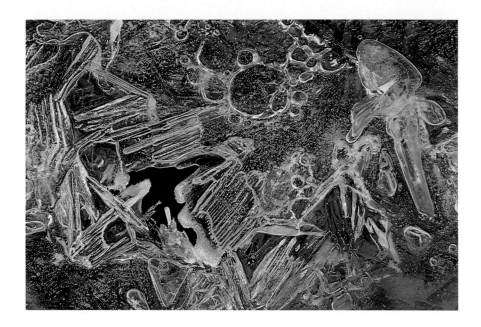

PATTERN IN ICE OVER STREAM
Nikon F3, Nikon 80–200mm zoom lens,
Nikon 5T closeup lens, Kodachrome 25

RAINDROPS AND HAWKWEEDS IN GRASSES
Nikon F4, Nikon 105mm macro lens,
Nikon 1.4X teleconverter, Fujichrome 50

It had rained all morning, a slow mist that saturated everything. By afternoon, it was chilly and damp but at least there were intermittent moments with no rain. The workshop group that Larry West and I were teaching headed out to explore the surrounding area. We had no particular spot in mind, so we just drove down a dirt road to see what we could discover. We turned a corner by an old field that we'd driven by a dozen times and never noticed before, but now it looked different because of the rain.

I was amazed by the responses when we pulled over. "We're not going in there, are we? We'll get soaked. Those grasses are at least knee-high! What's there to photograph anyway?" Most of the group wouldn't get off the road. But the ones who did shot a great deal of film that day. Our response to the shouted question of "What are you finding out there?" was a unanimous "Come and see!"

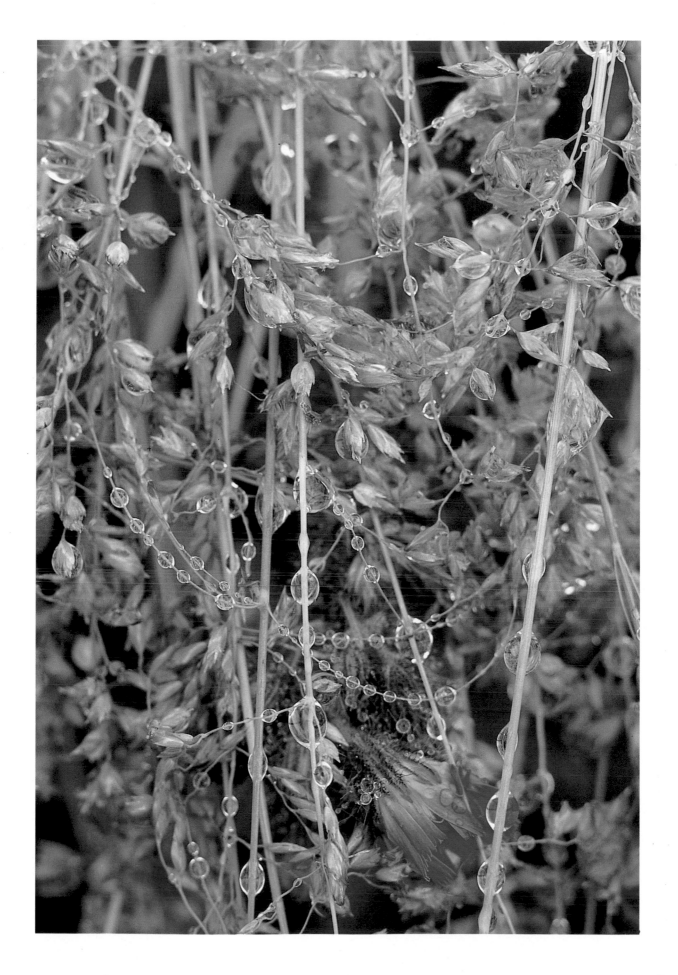

A SENSE OF PLACE

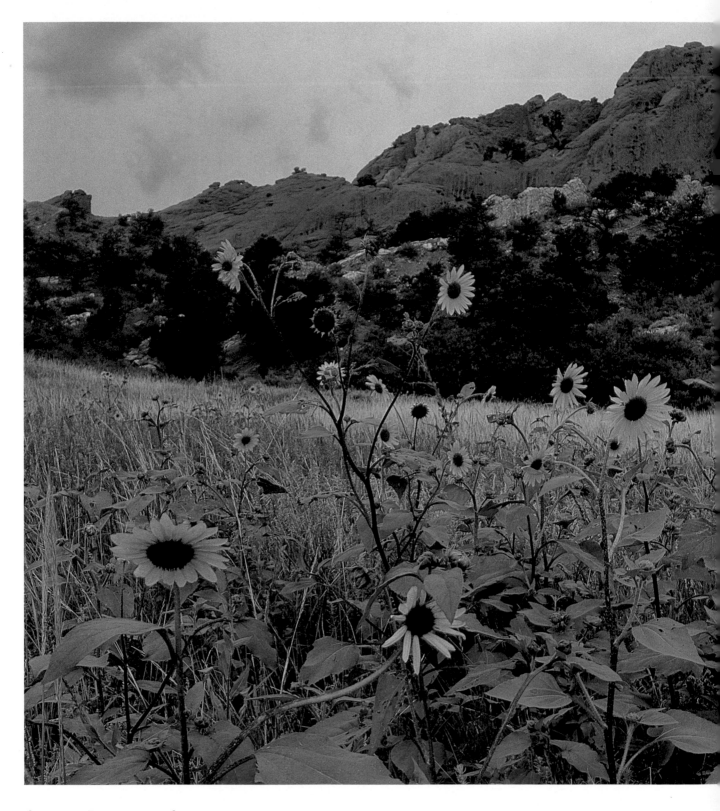

SANDSTONE FORMATION AND SUNFLOWERS
Nikon F4, Nikon 35mm lens, Fuji Velvia

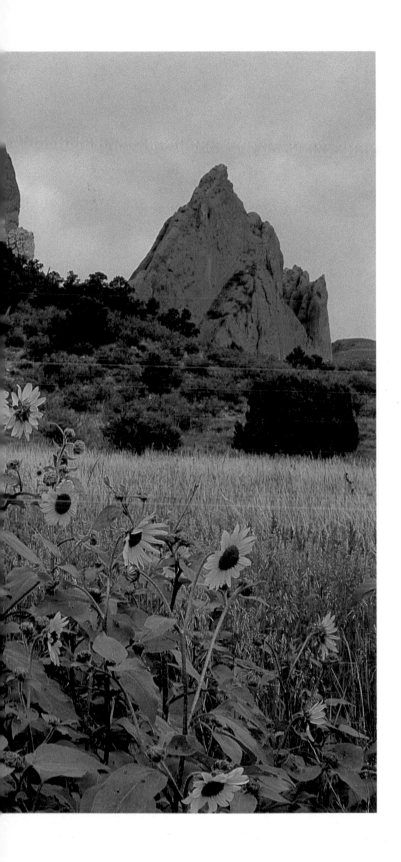

A SUCCESSFUL PHOTOGRAPH AFFECTS MANY OF OUR SENSES. IT EVOKES A DEFINITE FEELING FOR A PLACE AND SHOWS US WHAT IS THERE, WHILE IT LETS OUR SENSES PLAY, BROADENING LAYERS OF ASSOCIATION IN OUR MINDS AND MEMORIES. CAN YOU HEAR A CRASHING WATERFALL OR SMELL A MEADOW OF FRAGRANT FLOWERS? CAN YOU FEEL THE FROST OF A WINTER DAY? YOU CAN EXPERIENCE A PLACE BEFORE YOU'VE EVER BEEN THERE.

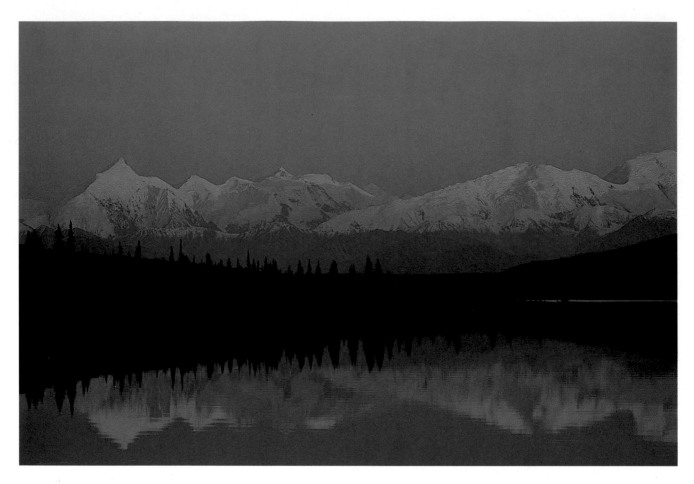

ALPENGLOW
Nikon F3, Nikon 50–135mm zoom lens,
Fujichrome 50

Standing at the edge of Wonder Lake in Denali National Park and watching the twilight alpenglow develop on the Alaska Range, I felt a sense of peaceful content grow within me. I was excited to watch the play of color on the peaks being reflected in the water, but at the same time the serenity of the situation overwhelmed me.

Technically this picture wasn't that hard to make, although it required some logical thinking before I tripped the shutter. Part of me didn't want to do any thinking; I preferred to just stand and observe the light. At last, the photographer side in me prevailed and out came my camera. I composed so as to leave a great deal of sky high in the frame in order to emphasize the airiness of the situation. Moving the mountains to the top third of the frame brought in too much of the dark foreground, letting an ominous note intrude on an experience that was anything but menacing.

To figure out the exposure, I reasoned that the sky was a light tone while the snow on the mountains was even lighter. If I placed the sky as "light," or 1 stop open from a meter reading taken directly off it, everything should fall into place. I tipped my camera up, zoomed to the longest focal length to narrow the angle of view, and metered only the sky. Then I compensated the one stop, recomposed, and took the picture. But I stayed at Wonder Lake until it was absolutely dark.

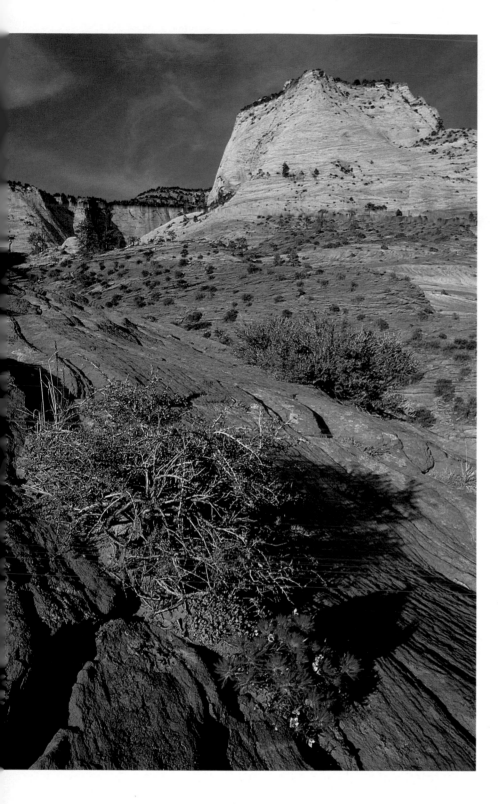

SANDSTONE BEDDING STRIATIONS
AND DESERT PAINTBRUSH
Nikon F3, Nikon 24mm lens, Fujichrome 50

One way to elaborate on a story is to present the characters in the context of their environment. You can do this photographically by using a wide-angle lens and shooting from very close to a foreground object. This technique shows how different parts of a scene interrelate and forces the viewer into an active participatory role. Although this approach isn't new, it is still extremely powerful.

When you look at this picture of sandstone and desert paintbrush, which I took in Zion National Park, you should notice several elements. First, my camera position was obviously very low and close to the paintbrush. Also, the light is the strongly directional sidelight of late afternoon. Finally, there is extensive depth of field. For this picture, I didn't focus my 24mm lens by looking through the viewfinder; instead, I used the hyperfocal distance scale on the lens to set the focus. I took this shot at *f*/22, but I set the focusing ring of the lens using the *f*/16 marks on the hyperfocal scale. Whenever I use the hyperfocal scale, I normally set my focus using the marks for 1 *f*-stop open from my shooting aperture to ensure that the resulting depth of field covers both near and far points. The near distance on the scale readout was 2 feet, so I positioned my camera on a tripod at that distance from the flowers.

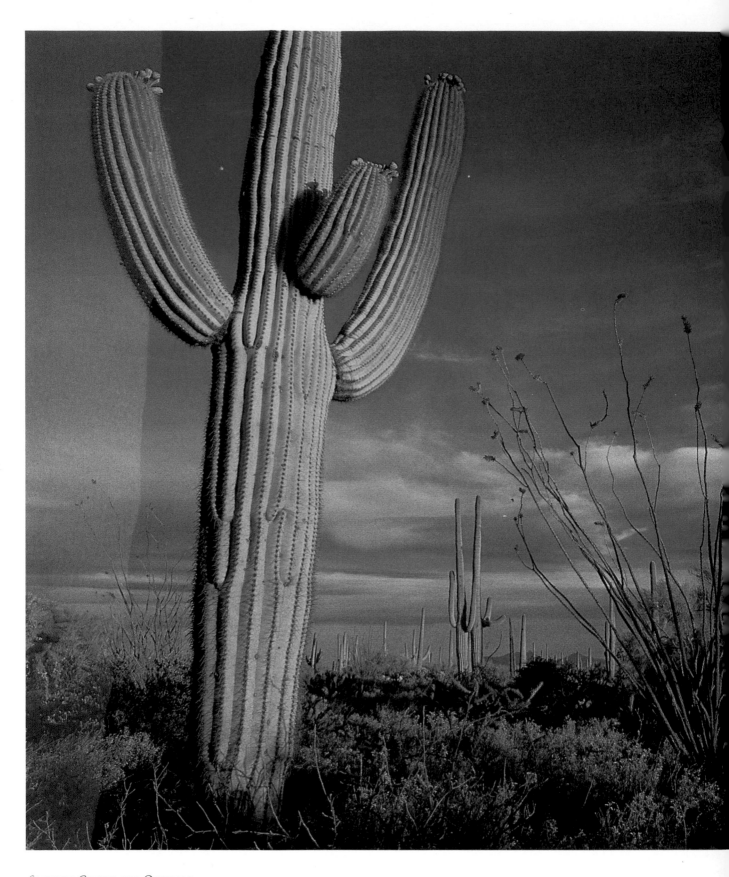

SAGUARO CACTUS AND OCOTILLO
Nikon F4, Nikon 35mm lens, Fujichrome 50

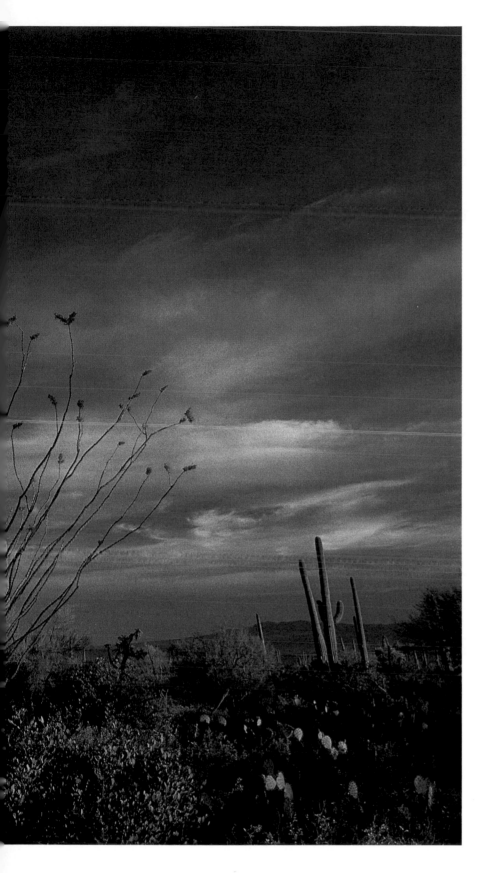

Most visitors see the desert at exactly the wrong time of day. They wait until late in the morning to get started and then leave by midafternoon. But the hours between 9:00 AM and 5:00 PM are not the time to be in the desert because the overhead sun bakes and bleaches. It is far better to be out at the very edge of light, those moments at the beginning or end of the day.

I took this photograph about half an hour before sunset, when the desert is pleasant. The light coming from close to the horizon provides definition and pleasing color instead of harsh shadows and washed-out hues. Here, I wanted to show what I enjoy about the desert: that it can be serene and peaceful only if you are there at the right moment. I've been kidded a lot for calling this type of light "sweet light," but it is the best description I know.

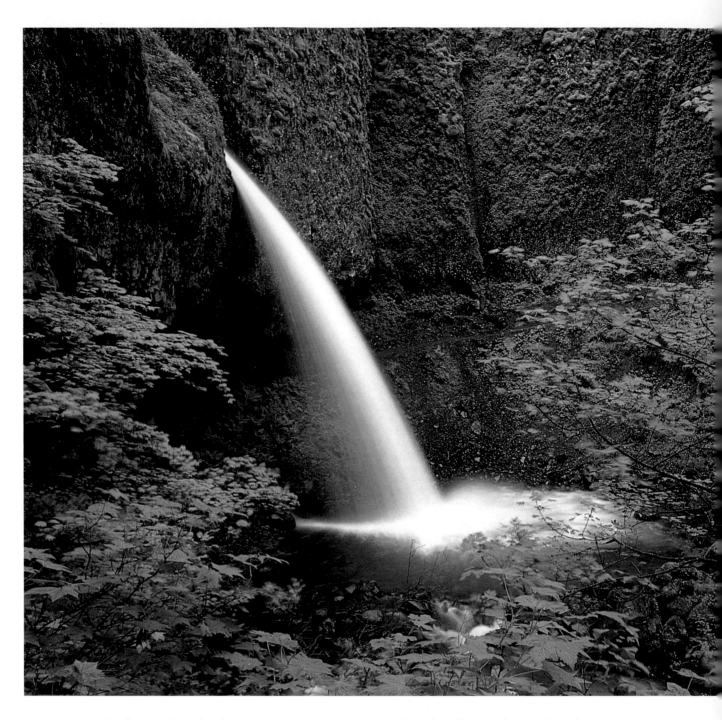

Upper Horsetail Falls is in the Columbia Gorge scenic area located just east of Portland, Oregon. Interstate 84 runs through the gorge beside the Columbia River, and thousands of people in cars zoom along it every day, seeing nothing but the white lines on the road. But even if you turn off the interstate and follow the twisting old highway, you still won't see the Upper Horsetail Falls. You'll discover only the Lower Horsetail Falls, which are about 50 feet off the old road. When you start up the half-mile-long trail to the Upper Falls, you find yourself almost alone. Even though these beautiful falls are close to a major metropolitan area, and not far off a paved road, they often remain unseen.

The hardest part in actually taking this photograph was to find a vantage point where I could see the falls. A trail curves through the forest and loops under the waterfall itself, but the dense growth of trees and undergrowth restricts your vision. By using my 24mm lens, I was able to stay close to the falls and eliminate some of the problems yet still show the surroundings. I used a very slow shutter speed, dictated by the low light level and the *f*-stop I used, knowing full well that the flowing water would blur into a solid stream.

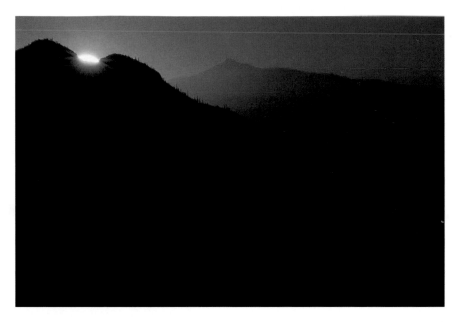

MOUNTAIN RIDGES AT SUNRISE
Nikon F3, Nikon 300mm lens, Fujichrome 50

The most dominant part of this picture is something that isn't there. The black expanse of the shadowed mountain lacks detail, yet this area commands how you deal with the photograph. Because it is such a large segment of the entire frame, it forces your eye to zero in on the sun just appearing in the notched mountaintop. The solid blackness emphasizes the time of day, echoing the idea that it was pitch dark moments before, making it impossible to see anything, and now it is first light.

A secondary and far more subtle theme is also present. There is a strong diagonal line following the ridge line from the sun toward the lower right of the frame. You can't see this line entirely; the beginning is visible against the diffused glow of the second ridge while the end disappears into the darkness. But this line reinforces the implied action that is just about to take place. The sun will rise and light will cascade down the mountainside. You anticipate the moment when all this brilliance will flood into the scene in the same direction as the diagonal line.

I dealt with two problems while taking this photograph at Saguaro National Monument in Arizona. First, I had to anticipate where the sun would rise, and then position my camera so that the sun fell into the notch. Second, I had to determine exposure. I aimed my lens up and metered only the sky before the sun appeared over the ridge. Using these exposure values, I then recomposed and shot at the exact moment the sun first appeared.

UPPER HORSETAIL FALLS
Nikon F4, Nikon 24mm lens, Fujichrome 50

As autumn arrives, the thermal area of Yellowstone National Park become places of mystery. The tourist masses of summer are gone, and the cool temperatures cause thick swirls of steam to drift through the trees. The landscape is obscured and then suddenly reappears only to quickly vanish once more as winds play. Frost builds quickly on any object near the steam vents, outlining yet camouflaging the underlying shapes. One of the best places to experience this transformation of the familiar is Norris Geyser Basin. You must be very careful working in the area because moving off the trail can be destructive and potentially dangerous. However this in no way limits your photographic possibilities, especially if you spend several hours at Norris.

Photographing along the edge of a large pool, I was particularly struck by the way the trees on the far bank appeared and disappeared in the mist. It was just a few degrees above freezing. I could touch the ground and feel the warmth of the subterranean heat, yet only inches above the surface frost coated the grass blades. Using my 105mm lens, which gave me some reach but also narrowed down the picture angle, I framed vertically and stopped down for maximum depth of field. As the steam drifted in and out, I shot a number of frames; each one is slightly different. In one photograph the trees are hidden, while in the next frame they stand starkly outlined. I liked this picture best, where the cold mystery is evident.

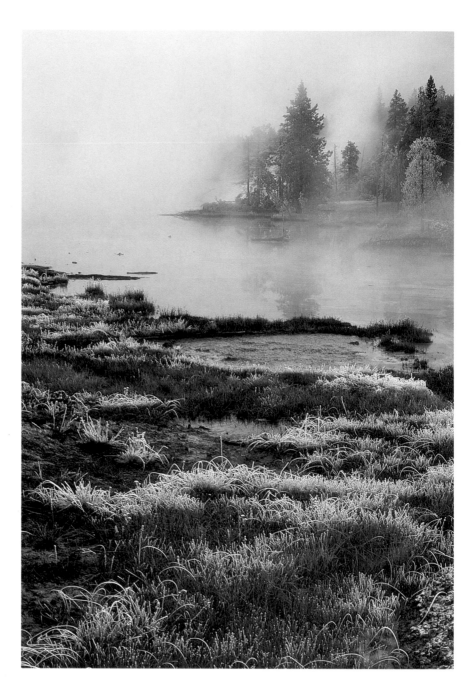

FROST IN THERMAL AREA
Nikon F3, Nikon 105mm macro lens, Kodachrome 25

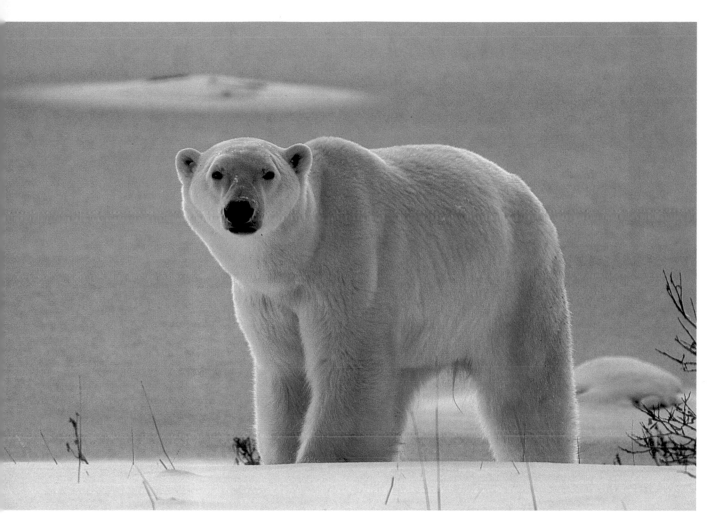

POLAR BEAR
Nikon F3, Nikon 300mm lens, Fujichrome 100

Polar bears amaze me. On one hand, they are power personified, massive and quick, a controlled force ready to explode. On the other hand, they are so adorably cute at times you can't help but be anthropomorphic. Without a doubt, the best and easiest place to see and photograph polar bears is Churchill, Manitoba. Of course, you can't just walk out on the ice and approach a polar bear—not if you want to live to develop your film. All photography is done from specially designed "tundra buggies." These are unique four-wheel drive vehicles with giant low-pressure tires that enable you to shoot out of open windows safely above the bears. As strange as it sounds, you slowly stalk the bears in these vehicles, getting as close as possible without affecting their behavior. Sometimes you can get remarkably close.

I've photographed bears in Churchill several times. As for photo equipment, the lens I work with most is a 300mm $f/4$ lens. Rather than just free holding this lens, I use a homemade shoulder stock and then brace against a beanbag lying on the window frame. To solve exposure problems, I just remember that a meter wants to make whatever I point it at a medium tone. But polar bears themselves are lighter than medium, and snow is even lighter than that. So for most situations, I meter the polar bear and then open up 1 stop more than the meter indicates, or meter the snow (snow that is not in the shade) and open up 1½ stops.

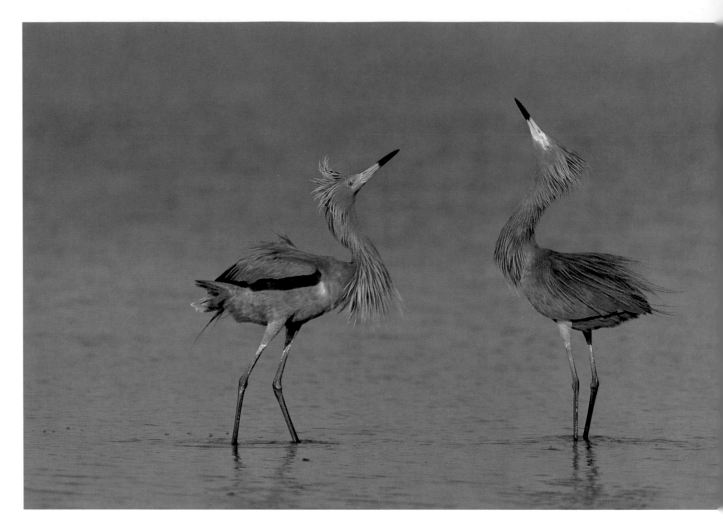

REDDISH EGRETS DISPLAYING
Nikon F4, Nikon 500mm lens, Fujichrome 100

Like many other people, I find birds and their behavior absolutely fascinating. And photographing birds is especially exciting because it demands quick reflexes as the action unfolds in front of you. I took this photograph in Ding Darling National Wildlife Refuge in mid-March when many reddish egrets had gathered. A long, winding, one-way gravel road runs through the refuge with saltwater areas on one side and brackish ponds on the other. Most visitors photograph from this road. By walking down the sloping road embankment, however, you can shoot more at a bird's-eye level—and end up usually about 20 feet closer to your subject. I shot this scene right from the water's edge. Because I didn't extend the tripod legs at all, I was kneeling in damp sand.

I like to use a large ball head on my tripod whenever I'm photographing birds and mammals. Leaving the ball head's controls slightly loose enables me to swing my lens around quickly as I keep my right hand on the motor-drive grip. With my left hand on the focusing mount of the lens, I can follow a subject and focus and always be ready to shoot. If I have time, I can lock the ball head down tight when the subject stops, but for a moving subject the loose ball head is ideal. Of course, I use a fast shutter speed to freeze any movement of the bird or the lens. Consequently, I end up shooting almost wide open most of the time. Critical focus then becomes even more important because there is limited depth of field to cover any errors. Shooting very high speed film is another choice, but keep in mind that as film speed increases, picture quality decreases.

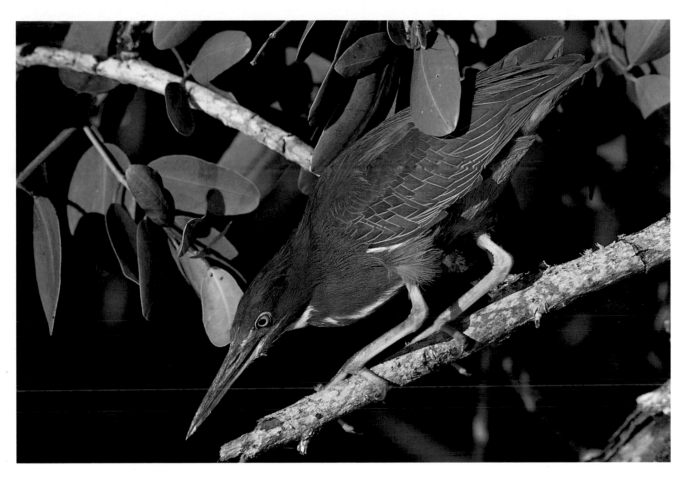

GREEN-BACKED HERON
Nikon F3, Nikon 300mm lens, Fujichrome 100

Do you ever connect a bird or mammal with a certain place even though it can be found in a number of areas? I associate the green-backed heron with the mangrove edges of Florida. These small birds are almost comical as they hunt from branches just above the water's surface, twisting their necks and stretching in order to bring a minnow into range. I've seen them hanging nearly upside down in their quest for food.

I took this shot in Everglades National Park with a 300mm lens, which tells you that I was in a location where the birds are used to people. In fact, without an incredible amount of work, I don't think that you would be able to photograph a green-backed heron outside of a well-visited place. I used an incident-light meter to determine exposure. This handheld meter measures the amount of light falling on a subject, so I didn't have to worry about the tonality of the bird or mangrove leaves. Since both the bird and I were in the same light, I simply pointed the spherical dome of the meter over my shoulder, in the direction opposite to the one my lens was pointed, took a meter reading, transferred the settings to my camera, and shot. Incident-light meters are perfect for this type of work.

Imagine driving down a road lined with flowers. You can do this with ease during April and May in the Texas hill country, which surrounds Austin and San Antonio. The roadsides are alive with flowers. There is no one exact spot for the best floral display; each year's bloom depends on a combination of factors, including earlier rains. It is best to simply pick up some county maps, talk with local people about where they've seen good flower displays, and then wander along every back road you can find.

This particular prairie, with its rainbow of Indian paintbrush and Texas bluebonnets, is located just outside the little town of Llano. I was almost ready to give up for the day when I discovered it. Finding a vantage point to shoot from was my biggest problem. I liked the twisted trees and wanted to use them as a contrast to the flowers, but the whole area was behind a fence on private property. I searched back and forth along the fence, viewing through different long lenses, worrying about how quickly the light was disappearing. Finally, I discovered a location, immediately set up my tripod, composed, and shot. Ever longer shadows were creeping across the flowers by the minute; I had time for only one composition before evening arrived.

SPRING PRAIRIE BENEATH OAK TREES
Nikon F3, Nikon 180mm lens, Fujichrome 50

JUXTAPOSITIONS

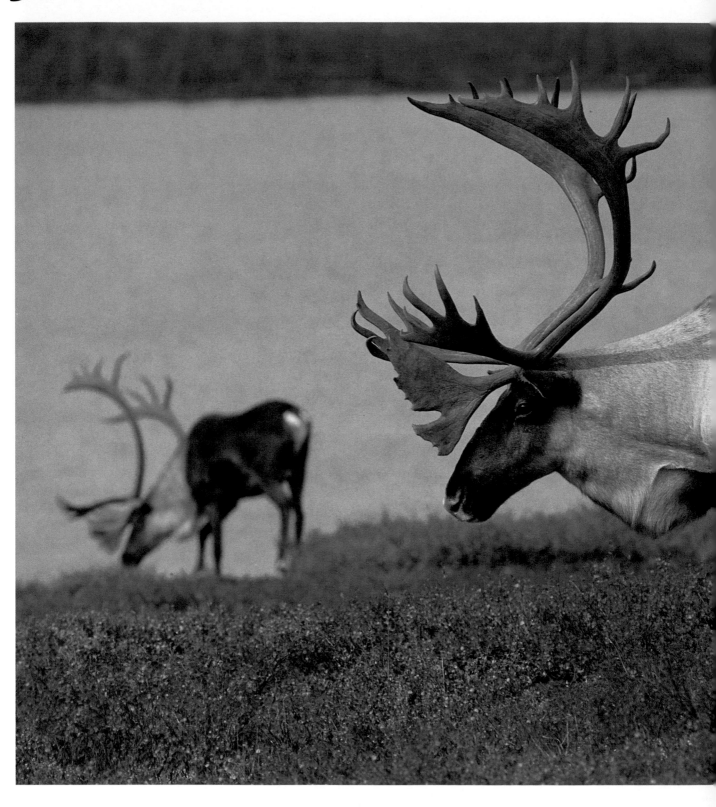

CARIBOU ON AUTUMN TUNDRA
Nikon F3, Nikon 300mm lens, Fujichrome 50

PHOTOGRAPHY LETS YOU
EMPHASIZE HOW YOU SEE
THE WORLD BY FRAMING
ONLY WHAT IS ESSENTIAL TO
YOUR VISION. YOU CAN PAIR
SUBJECTS, PLAY WITH
JUXTAPOSITIONS, REVEAL
DICHOTOMIES, AND USE
COMBINATIONS TO MAKE
VISUAL STATEMENTS.

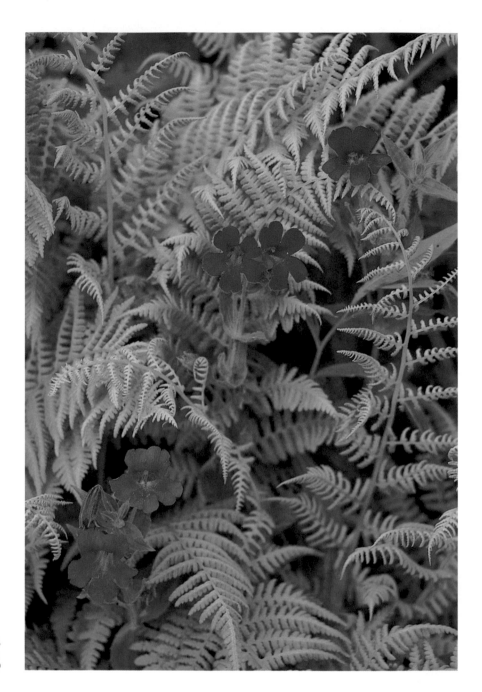

LEWIS' MONKEY FLOWER AND FERNS
Nikon F3, Nikon 105mm macro lens,
Fujichrome 50

This image is a good example of how contrasting colors add a feeling of depth to a two-dimensional photograph. Warm colors—reds, oranges, and yellows—appear to advance, while cool colors—blues and greens—seem to recede. I found these monkey flowers in Mt. Rainier National Park. What struck me about this particular group was its arrangement; the color of the flowers makes a brilliant slash across the green ferns. I carefully excluded from the frame all other blossoms that didn't add to this diagonal streak.

Wind is undoubtedly the worst enemy of closeup photography, especially when you're shooting long shutter speeds in dim light. Add long-stemmed flowers or ferns, and frustration levels rise quickly as you watch plants sway in the breeze. I shot this scene with my lens only 1 stop from wide open, trying to use the fastest shutter speed possible while establishing a little depth of field. Out of a roll of 36 exposures, I ended up with 6 sharp frames. This ratio, however, was better than the one my 6 x 7 camera produced; all 10 frames on the 120 film were blurred.

BLACKBERRY LEAVES
IN SPRUCE PLANTATION
*Horseman 985, Schneider 150mm lens,
Fujichrome 50*

I'd stopped to look at some vivid autumn maples along the edge of an evergreen planting. Trying to get the right vantage point, I backed into the plantation only to discover that it was choked with blackberry vines. Most were thickly tangled on the ground, but in some places larger vines had grown up through the branches of spruce and pine trees. I was more impressed with these contrasts than with the fall color I'd seen. The lives of two such different plants literally being interwoven intrigued me. After tripping through the vines for about 5 minutes, I found my subject and started setting up my camera and tripod.

I needed to hold sharpness on the plane of the blackberry leaves, but it was impossible to position my camera so that I could shoot straight down at them. I could've just shot at an angle to the leaves and stopped down my lens as far as it would go, but a persistent breeze

worried me. The only answer was to use the tilts on my view camera. I would've preferred to photograph this subject with my Nikons because 35mm equipment is much easier to handle and position, and the equivalent focal length, a shorter lens, would provide more depth of field. But I had to shoot from a slight angle, was limited to one spot, and had only a 105mm lens with a tilting feature for my Nikons, too long of a focal length for this photograph.

So I positioned the view camera, composed upside down and backward, tilted the lensboard, refocused, removed the groundglass, and inserted the roll holder. Then I made sure that the lens was closed, pulled the dark slide, metered the blackberry leaves with a handheld meter, allowed for bellows extension, set the shutter speed and aperture on the lens, and waited for the wind to stop. It's so much easier to use 35mm equipment!

If you saw this tree in midday light, you would never even notice it. It is actually growing right next to a heavily used public boat-launching site on a large Michigan lake. Throughout the summer, people with boat trailers and recreational vehicles come and go, noisily creating confusion and chaos—except at dawn. The early fishermen are already out on the lake, and the water-skiers haven't arrived yet. By using a long lens, I was able to position myself so that the rising sun lined up behind the tree trunk. I wanted to isolate the tree in the frame; I didn't even want the lake in the background. In order to do this and to hide a fisherman behind the horizon line, I shot upward from the very bottom of the boat ramp. I adjusted my tripod as low as it could go, and one leg ended up in the water as I sat on the lowest portion of the ramp. A heavy morning mist, low to the water, diffused the orange light.

I've always maintained that photography is far more time-dependent than place-dependent. Every place in the world—and any place in the world—is magical if you're there at the right time.

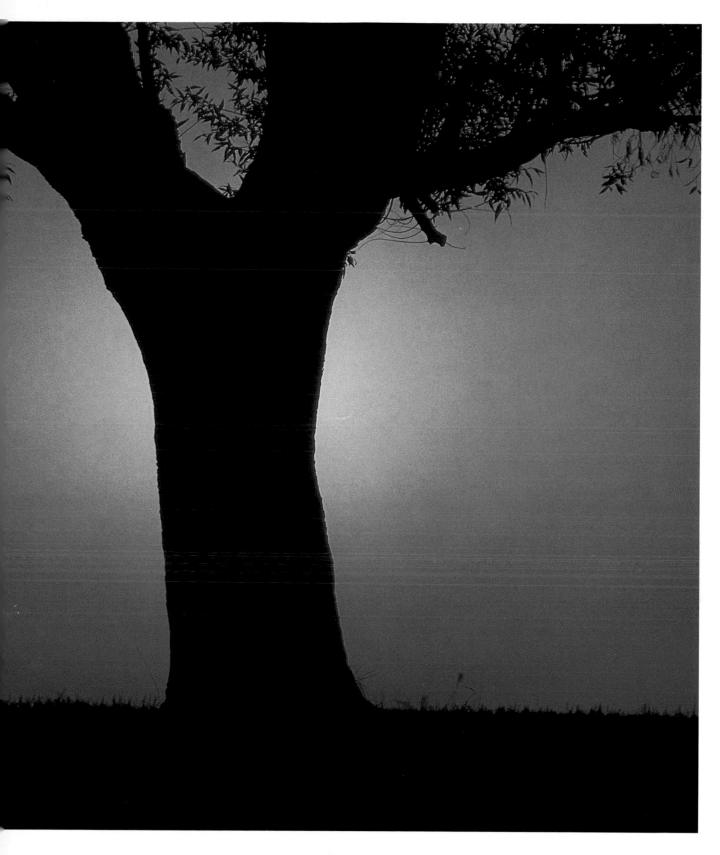

SUNRISE AND BLACK WILLOW TREE
Nikon F3, Nikon 300mm lens, Fujichrome 50

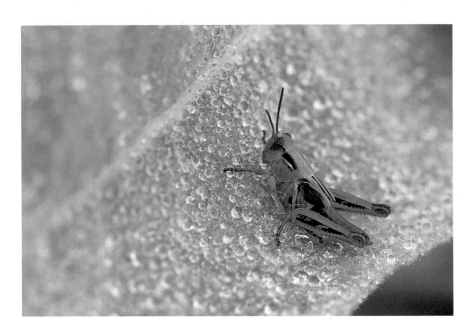

SPUR-THROATED GRASSHOPPER ON LEAF
Nikon F4, Nikon 105mm macro lens, Nikon 1.4X teleconverter, Fujichrome 50

At first, finding a grasshopper sitting on top of the raindrops covering a mullein leaf seemed strange to me. On second thought, however, it didn't seem peculiar at all—at least from the grasshopper's perspective. Rain is just another occurrence in its world, and a mullein leaf is just another open place to land.

I was crossing an old field right after a rainstorm when I spotted this grasshopper. I liked that it was essentially resting on top of the raindrops, so I pulled out my camera gear. Normally I would reach for a fairly long lens in this situation; grasshoppers don't tend to sit tight while I work a lens in close. However, I'd left my 200mm lens in my camera bag in the truck. The longest lens in my fanny pack was my 105mm macro lens, but by chance I also had my 1.4X teleconverter. Putting the two together increased the focal length a little, thereby yielding a bit more working distance. People ask me about the best lenses for field photography. This picture is good proof of my standard answer, "Whatever you happen to have with you at the time."

SENSITIVE FERN AND WILD IRIS
Nikon F4, Nikon 35mm lens, Fujichrome 50

The longer you stay in an area, the more you find to photograph if you really look. Too often, photographers are in such a hurry that the motion of getting someplace is substituted for the action of searching for subjects. Sometimes we're moving so fast, we zip right past potential areas without even noticing.

Some friends and I had stopped to investigate a wet cedar swamp area along the edge of a stream. We were on our way to a birch grove and paused only because someone in the group wanted to quickly identify a mushroom he'd seen from the car. I sulked, muttered "Let's go! Let's go!" and paced back and forth. I should've let go of my preconceived ideas and simply looked around. When I

finally relaxed, I started to see. Biologically speaking, this was a unique and interesting area. As I wandered down into the swamp woods, I came across a beautiful patch of sensitive fern; at the stream's edge a few wild irises were mixed in. Here was a photographic opportunity right in front of my eyes.

I used a 35mm medium-wide-angle lens because I wanted to shoot down on the thigh-high ferns. I isolated a single iris in the upper right, balancing it against the line formed by a fern frond running vertically on the left side of the frame. An earlier rain provided the drops on the leaves, and the overcast sky provided the perfect light for this situation.

I often look at my photography thematically. I search through pictures I've taken to see if there is a theme running through any of them—if there is a repeating structure beyond the apparent subject matter, composition, or design. When I find some motif that I've unconsciously developed, I then try to systematically keep my eyes open for additional photographic possibilities. In this way, I develop photo-essay ideas both for my own fun as well as for magazine or book pieces.

Such was the case with this picture. For several years, I've been in the habit of watching for "tracks and traces," the small notations left by an animal's passage. These include a footprint in frost or a game trail through sedges. Feathers are another obvious subject, and are very photogenic as well. I came upon this scene on the tundra on St. George in the Pribilof Islands of Alaska. I was there to photograph sea birds but it was too wet one morning to use long lenses, so I threw a small day pack across my shoulder and went exploring. The island was covered with lupine in full bloom, and the misting rain intensified the richness of the color. While I was working on one particular scene, I discovered this small feather next to some tiny new lupine leaves, both covered with rain droplets.

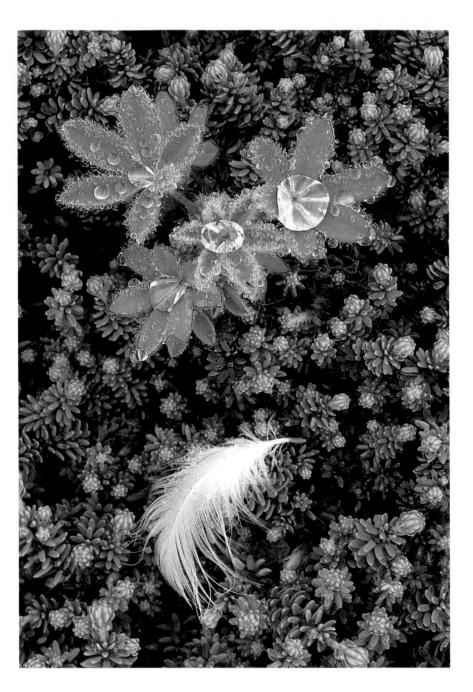

RAINDROPS ON LUPINE LEAVES AND FEATHER
Nikon F4, Nikon 105mm macro lens, Fujichrome 100

WILLOW PTARMIGAN FEATHERS
IN ALPINE BEARBERRY
*Nikon F3, Nikon 80–200mm zoom lens,
Nikon 4T closeup lens, Fujichrome 50*

I was hiking across the tundra in Denali National Park in early September, heading toward a couple of caribou I'd seen from the road. Before I was anywhere near them, they decided to move on so I gave up. Walking back to my car, I crossed an open area of bright red alpine bearberry, which was far easier than struggling through the dwarf birch and willow. Scattered across the brilliant bearberry were the remains of a willow ptarmigan, which had probably been killed a day or two before. Feathers were here and there, but these pure white ones, which stood apart from the others, stopped me. Here was a story reduced to its most basic essentials.

I wasn't totally prepared for closeup photography. I was carrying my 500mm on my tripod, but I almost always have another lens with me, usually in a fanny pack, when I'm photographing large mammals. Luckily, I had my 80-200mm lens and a closeup lens, too. I shot from the lowest tripod position possible, trying to line up the camera with the feathers. I had to frame a little tighter than I wanted in order to avoid a bare spot in the lower right. Determining the correct exposure was easy. I swung the lens over to one side, metered the medium-toned red bearberry, recomposed, and shot at that setting. If I'd metered as originally composed, the white feathers would've influenced my meter reading, telling me to stop down. I would've ended up with gray feathers in dark red bearberry, not what I wanted.

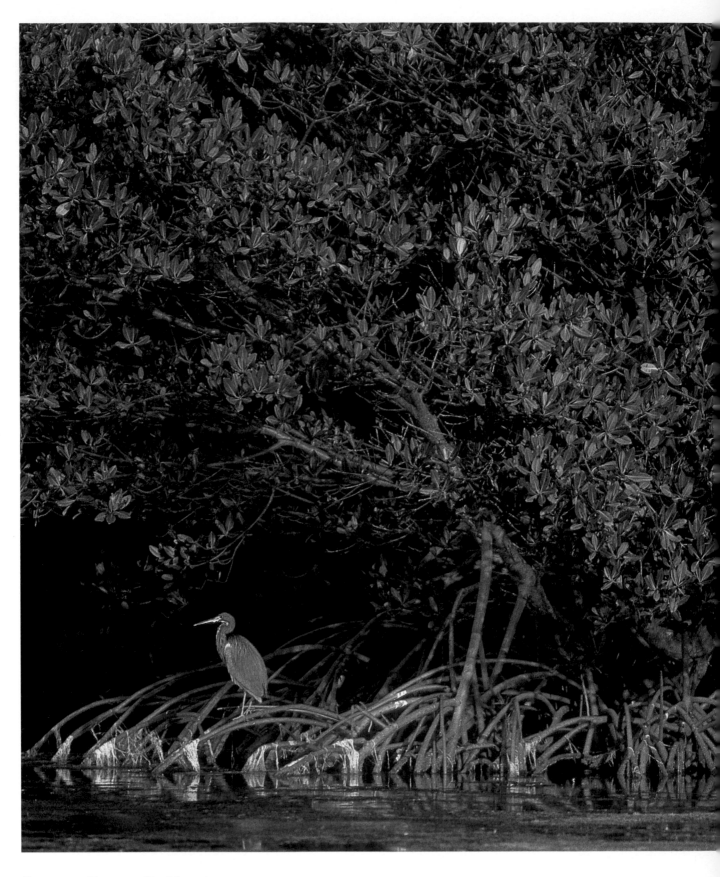

TRICOLORED HERON ON RED MANGROVE
Nikon F4, Nikon 500mm lens, Fujichrome 100

I love photographing birds and mammals because I'm keenly interested in natural history, but I'm not that excited about always taking standard, full-frame portraits of them. After all, they've been done many times before. Instead, at times I prefer photographing animals in their environments, as I did for this picture. Viewers must do some work here, too; they must be involved in the visual process in order to find the bird. This approach also conveys more information to viewers about tricolored herons and their habits and habitat. I'm certainly not suggesting that all wildlife photographs must show the long view, but environmental photographs do add another dimension to understanding the natural world.

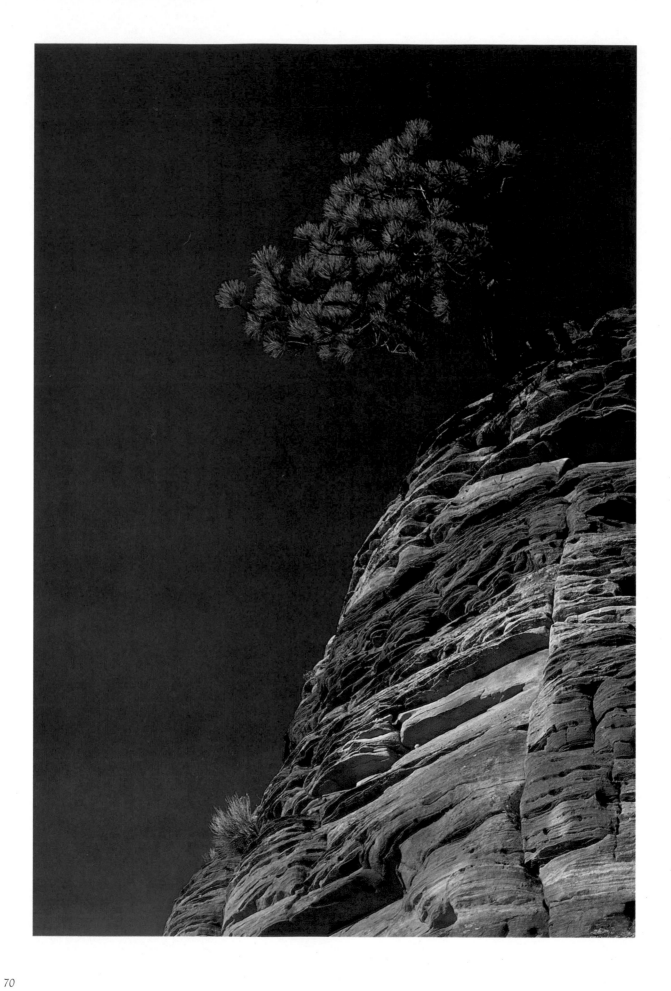

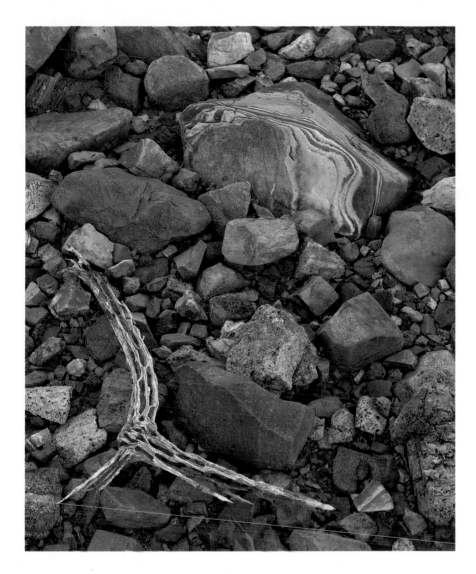

OLD CHOLLA CACTUS RIB
AND PETRIFIED WOOD
*Horseman 985, Schneider 150mm lens,
Fujichrome 50*

Saguaro National Monument lies just outside Tucson, Arizona. I was hiking along a dry wash, which is the dry bed of a seasonal stream, searching for a good location where I could shoot the sunset, when I came across this dried cholla rib near a brick-sized chunk of petrified wood. Both are commonly found all over the Sonoran desert, but what stopped me were the contrasts and similarities between the two. While both are the remains of once-living plants, one is ancient, and the other is young. Both belong to this desert, exhibit a weave of color and texture, and both are subtle in their presence.

I wanted to photograph the cholla rib and the rock exactly as I saw them, with the camera pointing down at an angle in front of me. I used my 6 x 7 view camera in order to make use of the front standard's tilts and to achieve overall sharpness. The desert and its dominions aren't suitable subjects for a soft-focus approach. Life there is hard-edged, distinct, and concentrated.

PONDEROSA PINE AND WEATHERED SANDSTONE
Nikon F3, Nikon 105mm lens, Fujichrome 50

I found this small ponderosa pine late one afternoon while shooting the east side of Zion National Park. When I first saw the tree, only the needled branches were in sunlight; the small trunk and the side of the sandstone pillar were in shadow. This created far too much contrast for transparency film, so I didn't waste any frames. I realized that if I returned the following morning, the entire tree and sandstone formation would be well illuminated since it would be facing the rising sun.

I was impressed by the tenacious grasp of the tree, both on the sandstone and on life itself. This is an extremely precarious spot to grow. When I started to compose my shot, I discovered one small bunch of grasses growing below the ponderosa. I carefully placed my camera to have both the tree and the grasses in focus. I liked the way the grasses act as a counterpoint to the tree, while the pitch of the shaped branches echoes the slope of the sandstone. By this time, there was full sunlight. I added a polarizer to saturate all the colors and eliminate any reflections from the needles. Then I used the "sunny *f*/16" rule, opening up 1 stop for sidelighting and 2 additional stops for maximum polarization.

SEASONAL SIGNATURES

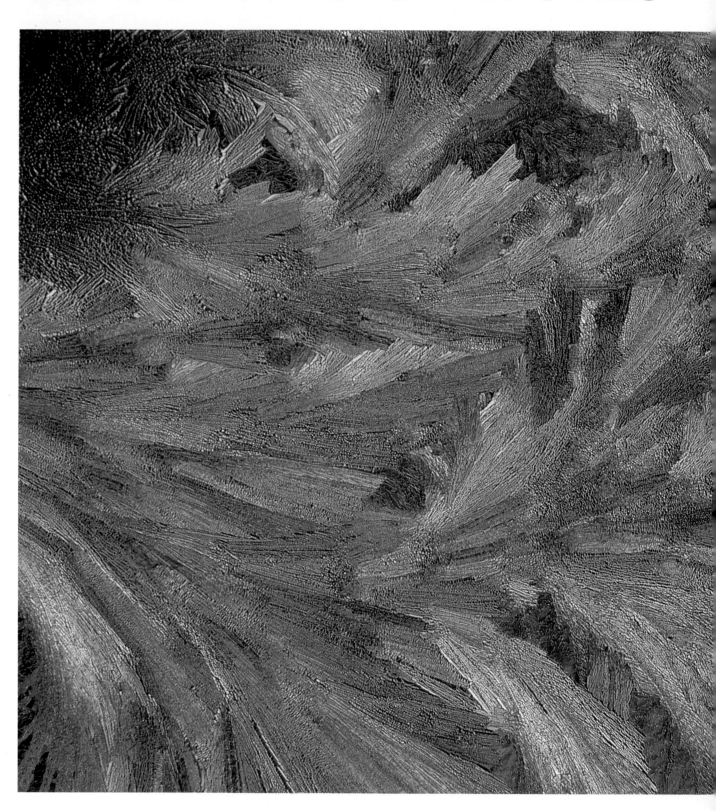

FROST PATTERN ON WINDOW
Nikon F3, Nikon 200mm macro lens, Kodachrome 25

PHOTOGRAPHS THAT
REFLECT THE SEASONS
ARE STATEMENTS OF A
DISTINCT TIME, INDICATORS
OF EXPLICIT EVENTS THAT
SUM UP OUR UNIQUE
EXPERIENCE OF THE
PASSING MONTHS.

While I was on a backpacking trip through New Zealand's Fiordland National Park, one morning began with a downpour and the rain continued to fall even harder. At one point, the trail went under a waterfall, and I didn't even notice a difference. My cameras and lenses were inside zip-lock bags that were inside a larger plastic bag tucked deep inside my pack. When I reached a trail shelter in the late afternoon, I unpacked my gear. I knew that I was in trouble when I poured about a quart of water out of my pack. Everything inside was soaked except my camera gear, which seemed dry. But the camera body that I'd used for a few grab shots earlier that day had stopped working. I wondered if the electronics were shorting out because of the dampness. I hung it over the shelter's woodstove by its neckstrap to see if it would dry.

Outside the shelter was a true rain forest (that is, not just a forest in the rain). As the sky cleared, I photographed this stream with my 24mm lens, showing both the stream and its surroundings. I realized that the very slow shutter speed dictated by the low light and the small *f*-stop I was using would blur the water. As to my dead camera, half an hour of dry heat took care of the problem, but adding a woodstove to my repair kit isn't in my plans.

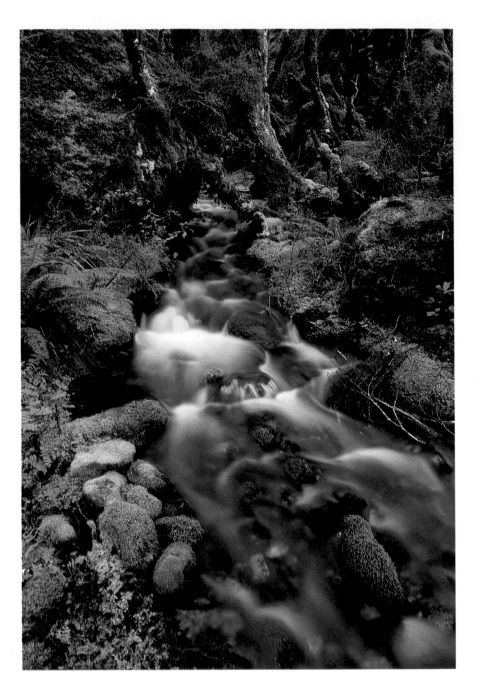

STREAM THROUGH RAIN FOREST
Nikon F3, Nikon 24mm lens, Kodachrome 25

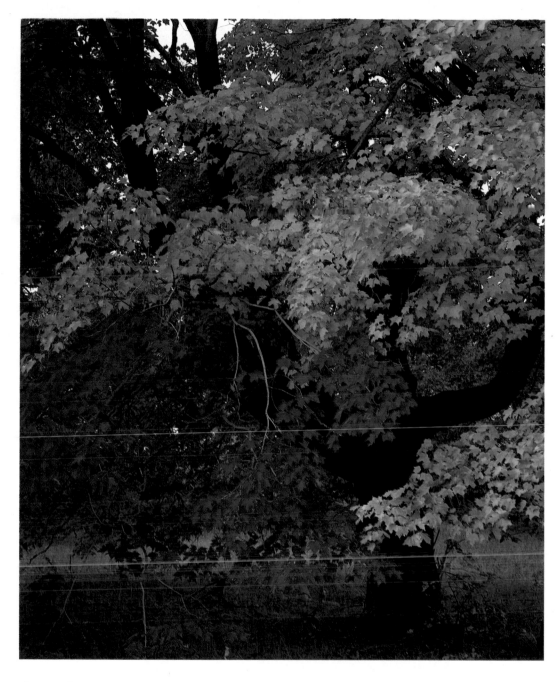

SUGAR MAPLE
IN AUTUMN
Horseman 985,
Schneider 150mm lens,
Fujichrome 50

If I were forced to choose the one time of year I like best, I would name autumn without a moment's hesitation—with one proviso. I would specify autumn in the beech/maple/hemlock woods of the northeastern United States, and even more specifically, the Great Lakes area. I love the cool weather, the overcast days, and the show of screaming color. Nothing else compares to this display, which at times borders on visual overload.

Sugar maples are the showiest trees of all. This particular old specimen was beside a long-forgotten northern Michigan farm lane, overgrown and tangled with blackberry vines. I saw this slash of bright red from the country road, which is why I stopped and walked in. I shot from a spot where the curve of the heavy branch toward the lower right filled an opening in the foliage. At the same time, it followed the form of the yellow leaves in the foreground. While the color of this maple tree is intense, I don't find its presence extreme in any way. Instead, the tree is patriarchal, peaceful, and serene; it reassures me. This is a tree I would like to know as part of my daily routine.

One of the best lights in which to shoot autumn foliage is when the entire sky is overcast. It creates a high, soft-white-light tent encompassing the scene. The contrast is low, and colors become saturated. I love this light so much that I almost hate to see sunny days in the autumn. Bright sunlight builds contrast, produces harsh shadow lines, turns leaves into a mass of confusing shapes, and tints the scene with blue from the open sky.

Overcast days do, however, have one major drawback. If a photograph includes any sky, it'll record on film as a featureless, washed-out, dull expanse. This isn't the look you want to achieve when the explosion of colors cries out for the exact opposite. One solution is easy: don't include the sky in your composition. Long lenses, with their narrow angle of view, enable you to eliminate the sky. If you use a normal lens, its angle of view will include the sky regardless of where you place your tripod. Pick up your telephoto. I often find myself using focal lengths in the 100–300mm range in the autumn to focus in on certain parts of the landscape.

I shot this group of sugar maples with my 300mm lens. Shooting into the woods, I was able to isolate a section that included all the autumn colors: red, yellow, orange, and green. And because I backed away from the trees rather than looked up at them, I was able to keep the tree trunks parallel to the sides of the frame. If I'd used a short-focal-length lens and tilted it upward, all the tree trunks would've appeared to converge toward the top of the frame, in a "keystoning" effect. Combining overcast light, peak fall color, and a long lens leads to dynamic photographic opportunities.

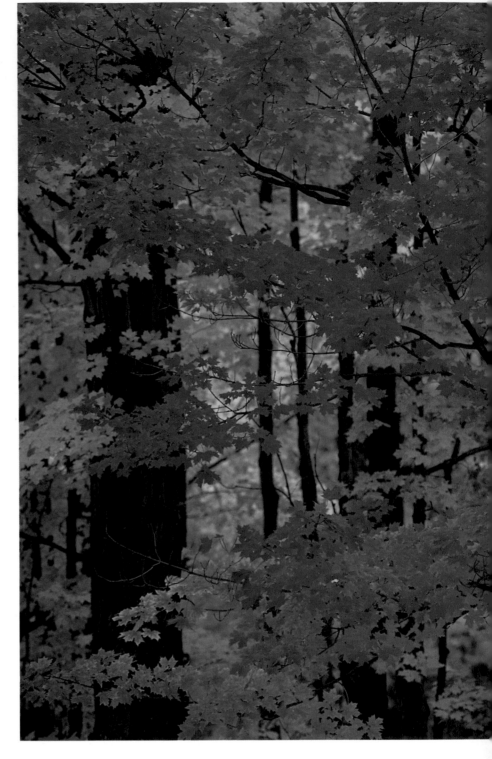

AUTUMN SUGAR-MAPLE COLORS
Nikon F3, Nikon 300mm lens, Fujichrome 50

MAYFLIES ON DANDELION
Nikon F3, Nikon 200mm macro lens,
Fujichrome 50

Some happenings are so quickly over that their occurrence each year marks a special page on the seasonal calendar. Such is the case with mayflies. These insects spend most of their lives as completely aquatic forms, living as long as four years in ponds and streams before emerging from the water in the last stage of metamorphosis. Adults last a few days at most. Some don't even make it through one day, emerging in the early evening to mate, lay eggs, and die before dawn. When they emerge, however, the numbers can be staggering. These mayflies were the result of an incredible overnight hatch from a large inland lake. Not a mayfly was to be seen the night before but by morning my truck was so covered with them, it seemed to have changed color and gained texture. Mayflies were everywhere.

I found this pair of adults clinging to opposite sides of a dandelion. In order to maximize depth of field, I needed to keep the camera back parallel with the plane of the insects. This meant I had to position my tripod as low as it would go. I used my 200mm macro lens both to narrow down the background and at the same time to isolate this small area.

Spring is the time of birth and regeneration; it is also the time, for good reason, associated with newborn animals. This young blue phase arctic fox pup was starting to explore its surroundings, but still wasn't ranging very far from the den where it was born. While I was photographing it, I could hear its brothers and sisters vocalizing barks and puppy growls, from behind and below rocks in the immediate area. Every few minutes, a little furry face popped out from around a rock.

Arctic foxes are considerably smaller than red or gray foxes. In fact, adults are only about 12 inches high at the shoulder, weigh around 10 pounds, and have a body length of 20 inches, with short legs and ears. Their compact bodies along with their dense fur are adaptations to their arctic habitat. Even though arctic foxes are cute and not nearly as shy as other foxes, I wanted to stay back while I was photographing and not add any more stress to this pup's life. So I used the longest lens I have, a 500mm lens.

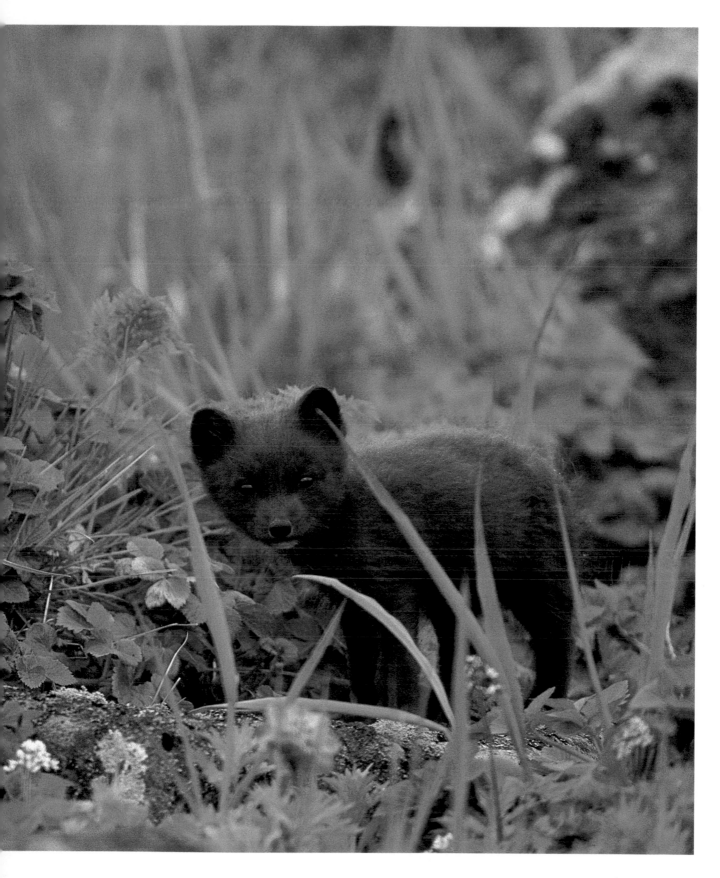

ARCTIC FOX PUP
Nikon F4, Nikon 500mm lens, Fujichrome 100

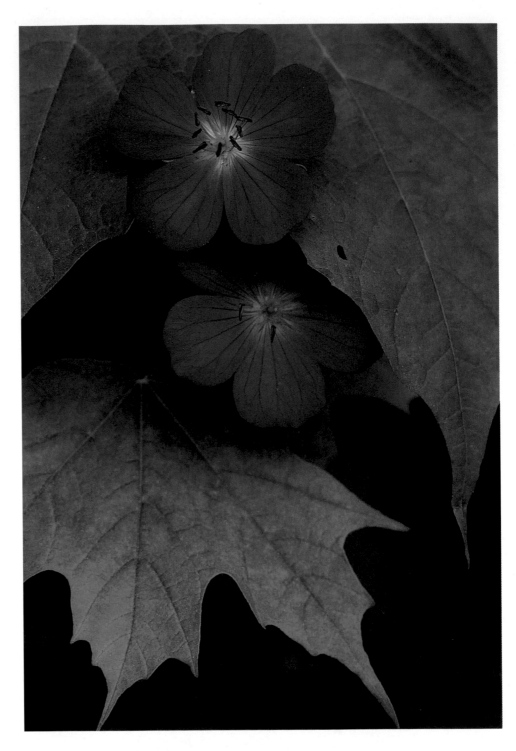

WILD GERANIUMS
AND SUGAR MAPLE LEAVES
Nikon F3, Nikon 105mm macro lens,
Fujichrome 50

The burst of blooming spring flora in the eastern hardwoods is always too brief. For a few days or at most a few weeks, spring flowers are everywhere. Then for a very short time, the flowers and budding tree leaves coexist. And for an even shorter time, both are in perfect condition, not yet showing the effects of the weather or insects. At this exact moment when spring is at its peak, when everything is new and unfolding, lush colors that I don't see at any other time abound. They are intense but not extreme, warm but not blistering, saturated but not syrupy thick. Then the canopy of budding leaves forms overhead, preventing light from reaching the forest floor, and the season is over.

I found these wild geraniums under the sweeping lowest branches of a spreading sugar maple. Some blossoms are hidden deep behind the new leaves; others, like the ones you see here, peek out tentatively yet expectantly.

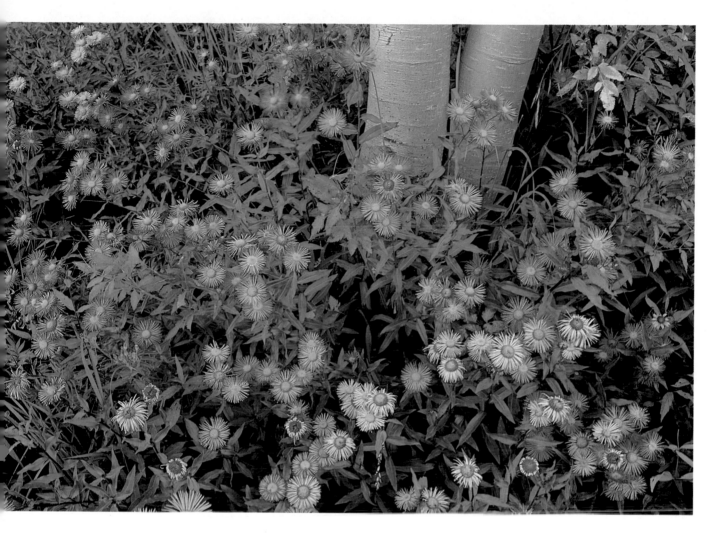

FLEABANE AND QUAKING ASPEN TRUNK
Nikon F4, Nikon 50 135mm zoom lens, Fuji Velvia

I was exhilarated to find this fleabane meadow as I was poking along a back country road. The only problem was that it was 10.00 A.M. on a bright, sunny, cloudless day. I knew that any photograph of the meadow would look absolutely terrible in that light. Luckily the meadow sloped downhill to the northeast, so late in the day while there was some light left for photography, the meadow would fall in shadow.

I returned too early. Like every other photographer, I've done my share of waiting but I haven't gotten any better at it. I figure out some shots, play with the equipment, explore the area—and wait, and wait. Some photographers claim they can previsualize exactly what a composition will look like in different lighting situations. I can't. I can tell if a scene has potential, but in the end I need to see the actual lighting. Here, the light made the difference. As shadows fell across the hillside, I came alive, madly shooting film. I started with large sweeps and slowly narrowed my vision until I finished with this tight shot. I kept the aspen trunks in the frame to provide a textural contrast to the fleabane and to add an environmental anchor, hinting to the viewer about the flowers' location.

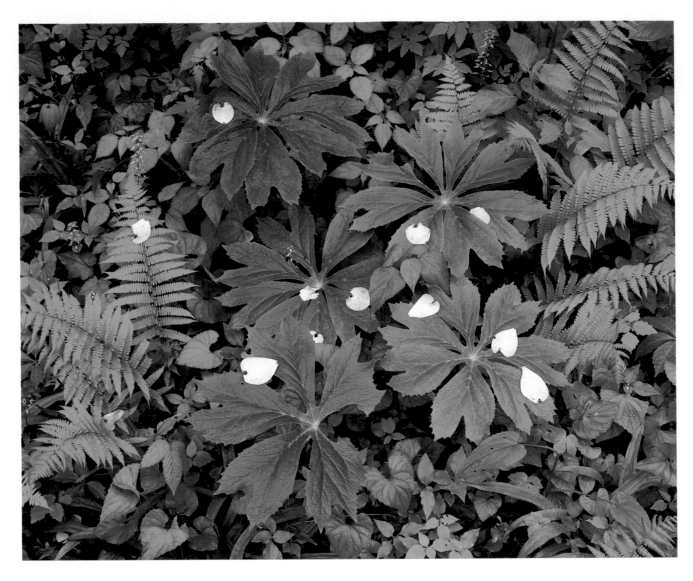

FALLEN DOGWOOD PETALS
ON MAY APPLE AND FERNS
*Horseman 985, Schneider 100mm lens,
Fujichrome 50*

When I found these fallen dogwood petals, it was either the absolute conclusion of spring or the very beginning of summer. I've always thought that there really should be eight seasons, the four that people always talk about and then the four periods of change. I suggest some titles for these new seasons: first to fall, earliest winter, start of spring, edge of summer.

In the southern Appalachians, the edge of summer is definite. Early May marks the last of the spring wildflowers with the opening of the forest canopy. The time of leaves happens almost overnight as petals fall and the world turns lushly green. I was camping in the Blue Ridge Mountains when an overnight rain brought down the few remaining dogwood blossoms. When I found these May apples and ferns in the morning, the rain slowly had become just a heavy mist. A normal lens gave me the perspective and working distance I needed but although I looked at this small scene through a Nikon, I settled for shooting it with my view camera. I could easily have used either camera, but the 6 x 7cm format framed my composition more the way my mind's eye saw it than the strongly rectangular 35mm format did.

The low level of morning light, combined with the misty overcast, gave me an exposure of around 8 sec. at the *f*-stop I needed. I doubled the time to compensate for reciprocity failure and hoped for the best. As an indication of how still it was that morning, every frame I shot is sharp.

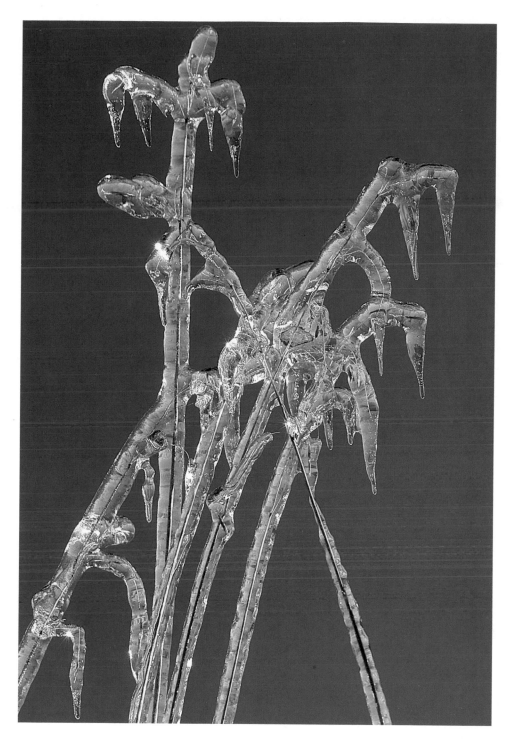

ICE ON MEADOW GRASS
Nikon F3, Nikon 80–200mm
zoom lens, Kodachrome 25

My wife and I spent one New Year's Eve at the house of some friends. It was raining when we arrived, but during the evening the temperature dropped. We didn't think anything of it, not even when the electricity went off. Then we started to hear the sound of loud cracks followed by tingling crashes. We looked outside to discover thick ice coating everything and tree limbs dropping from the weight. The ice, which didn't melt for days, provided some splendid photo opportunities. I shot these meadow grasses in a field just behind my house from a low angle, looking up toward the sky. Their size is deceptive; the grasses in the frame are actually about 3 feet high. The zoom lens I used was incredibly helpful, enabling me to compose and to crop exactly, since positioning my tripod in the ice wasn't easy.

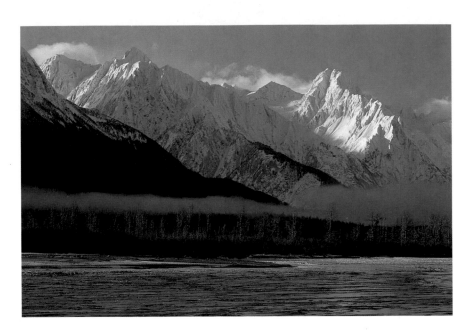

THE CATHEDRAL MOUNTAINS
Nikon F4, Nikon 80–200mm zoom lens, Fujichrome 100

In the Cathedral Mountains, vertical spires and peaks thrust heavenward while ridges seem to rise almost straight out of the sea. Determining exposure could've been quite a problem. The scene included areas of snow in both sunlight and shade, some deep black shadows, and a fog bank along a row of backlit cottonwood trees. In these situations, having a spot meter built into the camera, such as my Nikon F4, is a distinct advantage. It gives a very narrow-angle meter reading regardless of the lens used. Here, I zoomed my lens to the 200mm focal length to limit the metered area even more. I took a spot reading off the shadowed snow; decided that it should be light blue, which meant 1 stop open from what the meter said was a medium-toned placement; zoomed back to the framing I wanted; and tripped the shutter. A spot-meter function is one feature of the newer cameras that I applaud loudly and use quite often.

BALD EAGLE IN COTTONWOOD TREE
Nikon F4, Nikon 500mm lens, Fujichrome 100

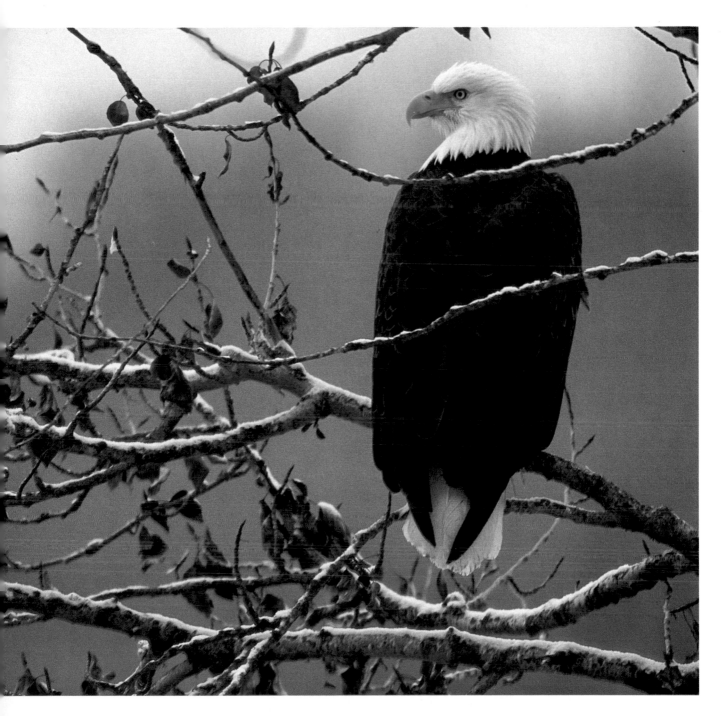

Every fall, more than 3,000 bald eagles gather along several miles of the Chilkat River near Haines, Alaska. The birds congregate here because of the last autumn salmon run. The Chilkat is a broad, braided river with many channels. Fortunately, the main current keeps one channel next to the road open while the rest of the river freezes over. As a result, the bald eagles often perch in the cottonwood trees lining the road, and during the salmon season, become accustomed to disturbances caused by people and vehicles.

There is one perfect time to photograph the birds. If you arrive too early in the fall when the river flows freely and the rain falls incessantly, the eagles are scattered for miles. And if you're there too late in the season, the river is frozen solid, the salmon numbers are down, and the eagles are leaving. The exact moment you want is when all of these factors are in equilibrium.

I took this photograph while standing on the shoulder of the road. The weather was fairly typical for this time of year: an overcast sky, the temperatures just below freezing, and some snow falling. Because I was standing on a rise above the riverbank where the cottonwoods grow, I could shoot directly into the tops of the trees without aiming my lens upward. I was able to use the far bank as a soft gray background rather than having a blank white area behind the eagle. I framed the eagle's head with tree branches, making sure not to merge any snow with its white head feathers.

REPETITIONS

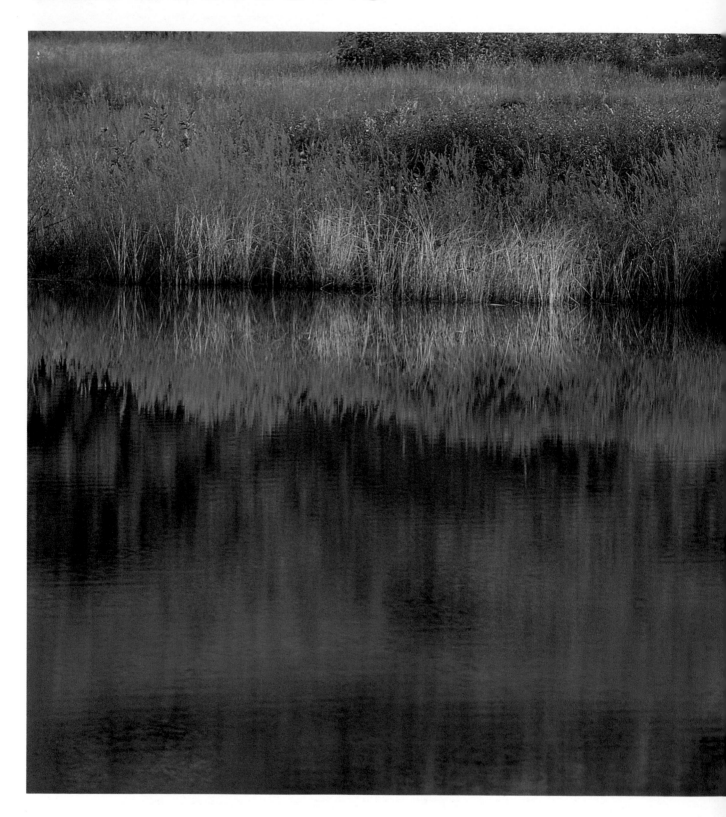

AUTUMN POND REFLECTIONS
Nikon F3, Nikon 300mm lens, Fujichrome 50

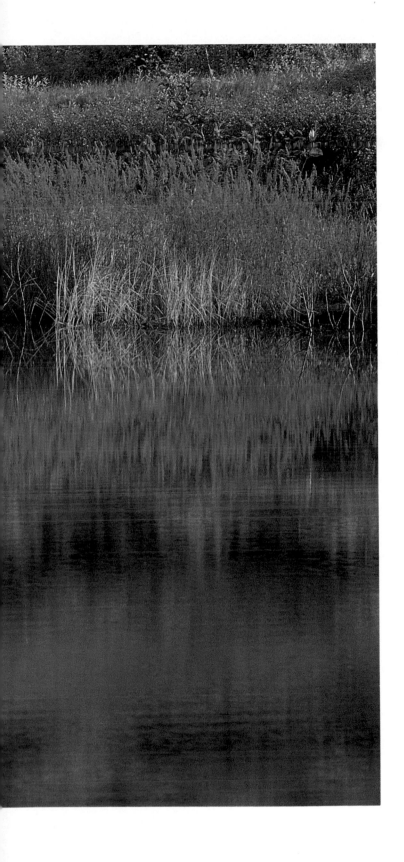

REPEATING A STATEMENT, RETELLING THE STORY A SECOND TIME OR PERHAPS A THIRD, WE LISTEN TO ECHOES BOUNCING BACK ONCE AGAIN. PHOTOGRAPHS CAN BE STRUCTURED IN MANY WAYS, BUT REPEATING THEMES WITHIN THE FRAME—WHETHER SHAPES, COLORS, OR LINES—STRENGTHENS A PICTURE WHILE ECHOING THE VIEWER'S OWN EXPERIENCES OF LIFE.

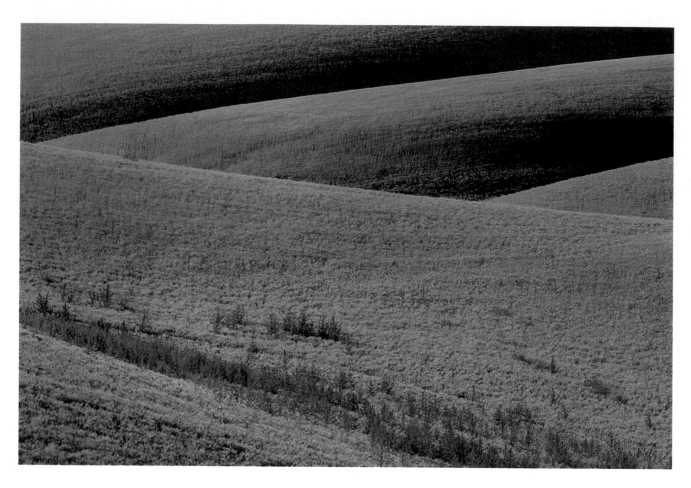

WHEAT FIELD
Nikon F4, Nikon 300mm lens,
Fujichrome 50

While driving around eastern Washington one late July when the wheat fields were turning gold, I found images leaping out at me continually. I either stopped and shot the scene or made a mental note of the location so I could return to it later, depending on the lighting at the time. The late-afternoon light during the last two hours of the day was the most spectacular. The dust from the fields hung in the air and diffused the warm sunlight, leaving it soft but directional and bathing everything in a magical glow. Now was the time to shoot.

From the road, I saw overlapping hills in a wheat field and used my 300mm lens to isolate one section of them. I chose an area where the distant ridgetops run parallel to each other, and the green plants in the foreground echo the line of the nearest field. The long lens also compressed the perspective—that is, I was looking at an area some distance away from me—and made the ridges appear to be much closer together than they actually are.

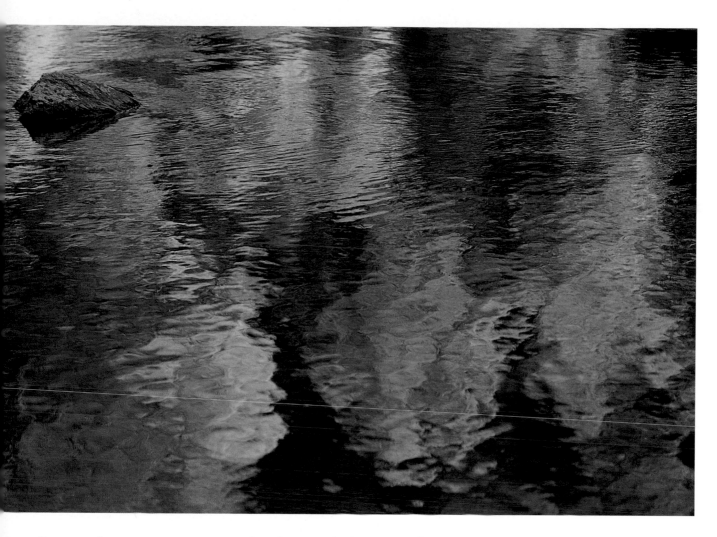

ROCK AND AUTUMN REFLECTIONS
Nikon F3, Nikon 200mm lens, Fujichrome 50

Tulip trees, also known as yellow poplars, line the steeply sloping banks of the Little River on the Tennessee side of the Great Smoky Mountains. In autumn, their leaves uniformly turn yellow (although this has nothing to do with their common name). The only road hugs the river's path, following every curve and curl and providing an intimate view of the waterway. By afternoon, the river is deep in shade while the hillsides remain in sunlight. This situation throws bright yellow reflections on the water.

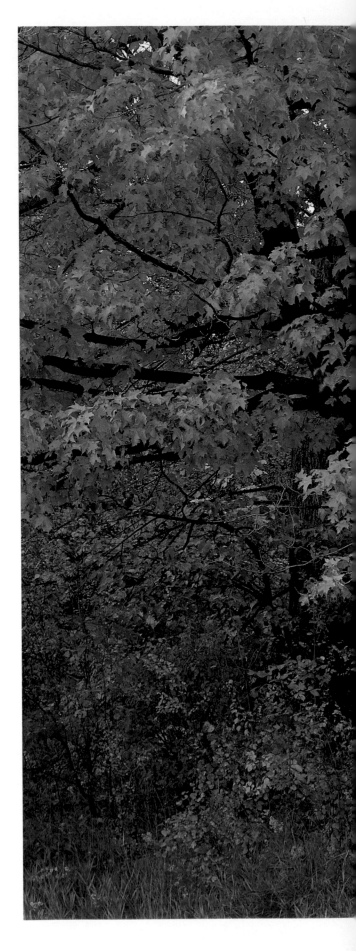

Autumn in the deciduous woods in Michigan has several
distinct stages. First, there is an early blush of color, indicated
by only a few leaves whose shades dare to hint at what is to
come. Then there is an equivocating period of mixture—
autumn hasn't made up its mind yet—with greens still
predominating but warm yellows, oranges, and reds starting
to appear. The third stage is the time of maximum color,
when every maple tries to outdo its neighbors. And finally
there is the period when the leaves fall, the tree trunks stand
starkly bare, and all of autumn is on the ground.

This is a photograph of the second phase. Tree after tree
echoes each other in a display of greens and oranges.
Hundreds of sugar maples repeat the same refrain: Autumn
color is here! Photographic images are everywhere on a day
like this because of the overcast sky, still air, and bold color.
Drive along any back road, walk down every sandy trail
through back woodlots, and always keep your camera handy.
It is hard to take a bad picture.

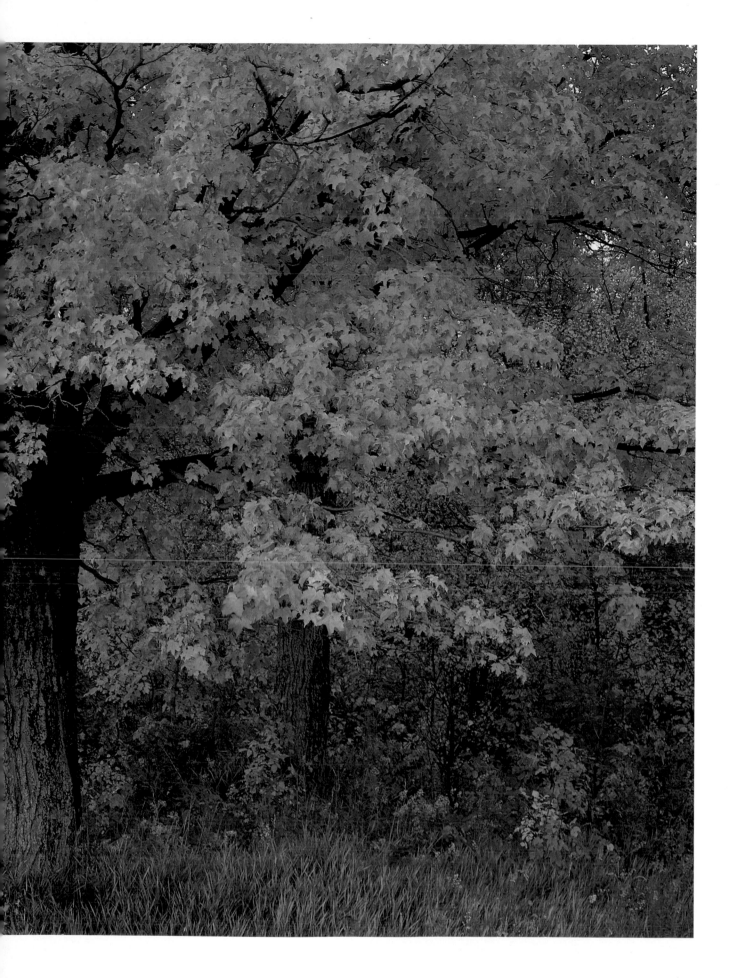

I was struck by how Western-hemlock boughs overlap, layer after layer after layer. Working in Olympic National Park, I pulled down a road near the campground to photograph flowers and ferns. Periods of rain, 10 or 15 minutes long, interrupted my photography; I gave up and retreated to my car to eat a sandwich and reorganize my wet equipment. So there I sat looking at trees in the rain when I finally became aware of what was right in front of me. Hemlock branches, sweeping gently toward the ground at their tips, make a wonderful repeating pattern.

After that discovery all I had to do was wait for the next dry spell in order to explore the area, searching for the best hemlock around. I found one that would enable me to shoot slightly downward, emphasizing the droop of the branches. I knew that the shadowed areas of the branches would record as deep green, almost black, since they were beyond the contrast range of my transparency film; this would keep the branch tips separate. I used my 50–135mm zoom lens, which is actually one of my favorite travel lenses, to crop precisely the section of the tree I wanted. Composing vertically also let me emphasize the layering effect.

WESTERN-HEMLOCK BOUGHS
Nikon F4, Nikon 50–135mm zoom lens, Fujichrome 50

AMERICAN ELMS
Nikon F3, Nikon 55mm lens,
Kodachrome 25

I shot these elm trees one February twilight in my backyard in Michigan with a
55mm lens that I'd bought more than 20 years ago and still use. This standard
lens was perfect for framing one elm within the branches of the tree in the
foreground. Because I needed extensive depth of field to cover the distance
between the two trees, I knew that I had to shoot at about f/22. But it was too
dark out to get a meter reading at that aperture, so I metered wide open and
then counted shutter-speed stops as I set the lens to the shooting aperture.
When I realized that the shutter speed would be quite a few seconds, I doubled
the time to let in another stop of light to prevent reciprocity failure.

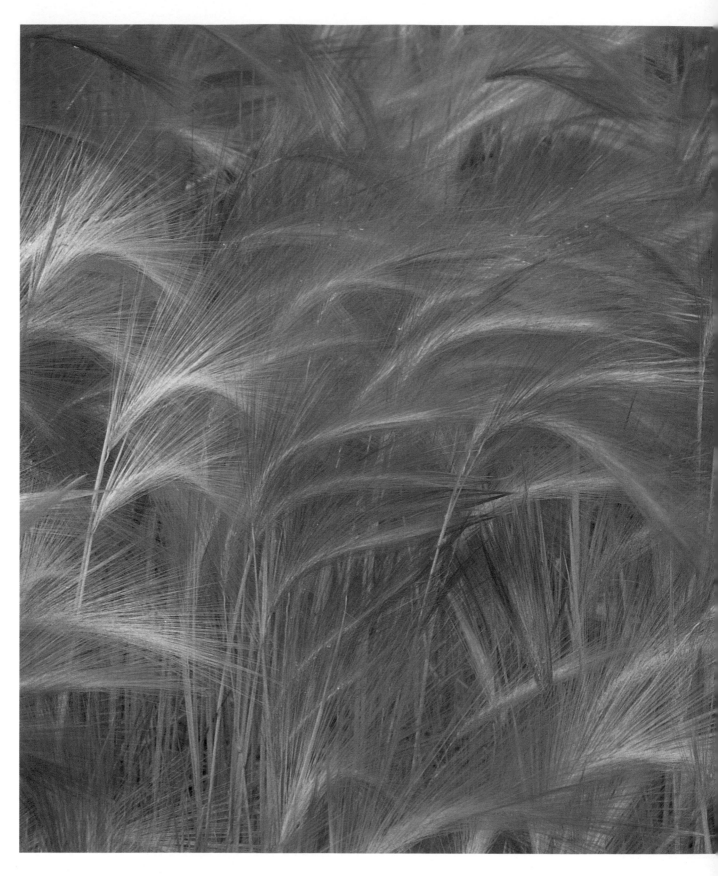

Foxtail Barley Grass
Nikon F4, Nikon 105mm macro lens, Fujichrome 50

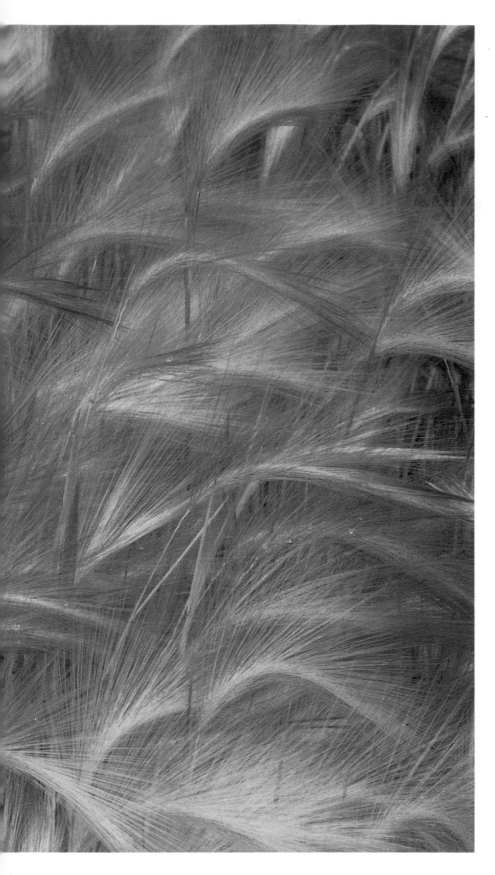

Foxtail barley is a fairly common grass, often found in areas where the soil has been disturbed. Roadsides are one of the easiest places to find it, but are one of the hardest places to try to photograph it. Even if you can avoid traffic, the blasts of wind from passing cars make the stalks sway continually. In fact, if you want to discover just what dead-calm air is actually like, watch this grass for awhile. The slightest breeze that goes unnoticed by you will make the heads tremble. Consequently, the biggest hurdle you face when photographing foxtail barley is your own frustration level. How long can you tolerate waiting for everything to stop moving?

I'm amazed at the gradations of color in these grass heads. As I photographed them, greens, reds, and tans flowed smoothly together yet changed completely depending on my viewing angle.

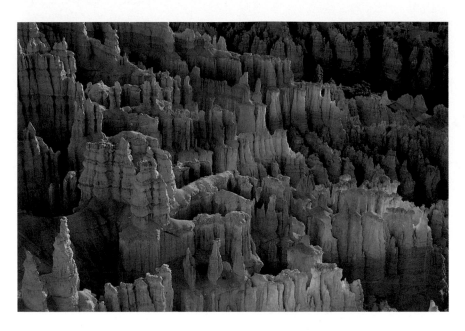

INSPIRATION POINT
Nikon F3, Nikon 50–135mm zoom lens, Fujichrome 50

Easter dawned cold and clear. With very few people in Bryce Canyon National Park so early in the year—after all, it had snowed the previous week and was only 20 degrees that morning—I was the only person at the Inspiration Point overlook. About half a mile away, the park service was holding an Easter sunrise service at, where else, Sunrise Point Overlook. Perhaps a dozen people were there, and it was so calm, so tranquil a morning that I could hear perfectly the service and the songs. The sun rose over the distant ridge and immediately the towered maze below me started to glow, the light reflecting and bouncing off myriad sandstone walls.

What a way to start the day! I remember standing there feeling in harmony with the world, at peace, content, and utterly amazed at the light show before me. And the light was what astounded me the most, seeming to radiate almost directly from the rock, opening shadowed areas and filling recesses. The rock and the light joined as one. Even now as I write about Bryce, the sight of that morning is fresh in my mind.

SUNSET
Nikon F3, Nikon 300mm lens, Fujichrome 50

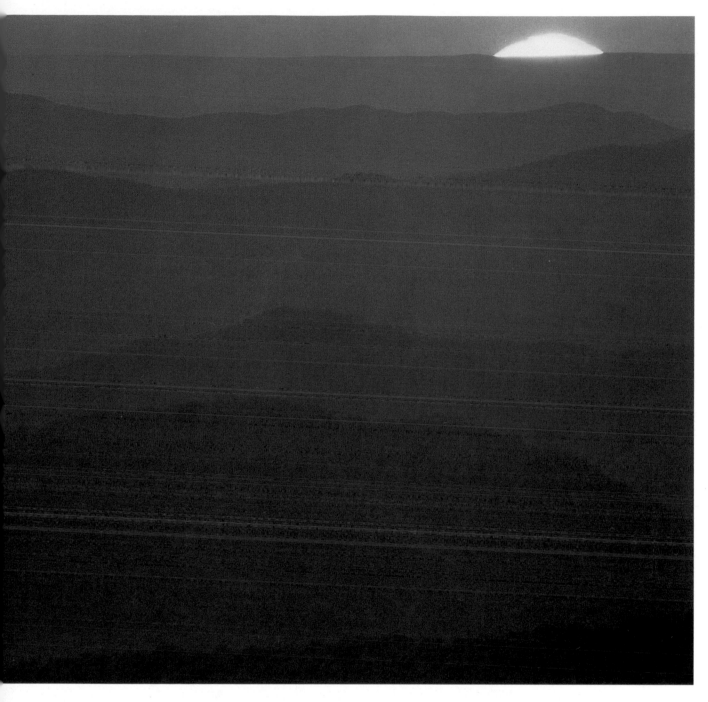

One of the most popular places for sunset views in Great Smoky Mountains National Park is the Clingmans Dome area, the highest part of the park. Shooting from here has two major advantages. First, the spot is easy to get to because there is a road that goes almost all the way to the top. And the vista from the parking lot at the end of this road is beautiful and isn't marred by any obstructions.

The view from here is spectacular. Stacked mountain ridges recede in the distance. I used a 300mm lens to pull in this section of the mountains. A long-focal-length lens also magnifies the sun, making it as large as people think it

should be. After all, you can achieve a larger image only two ways: use a longer lens or move closer to your subject. Trying the latter approach for a sunset isn't too practical.

This photograph from Clingmans Dome truly is a seasonal one. In October, the sun sets in just the right location, not too far north, and there is enough moisture in the air to create the misty haze separating near and distant objects, a visual phenomenon generally called "aerial perspective." But keep in mind that it gets much colder up here than you'd expect when you're waiting for the sunset. I speak from experience.

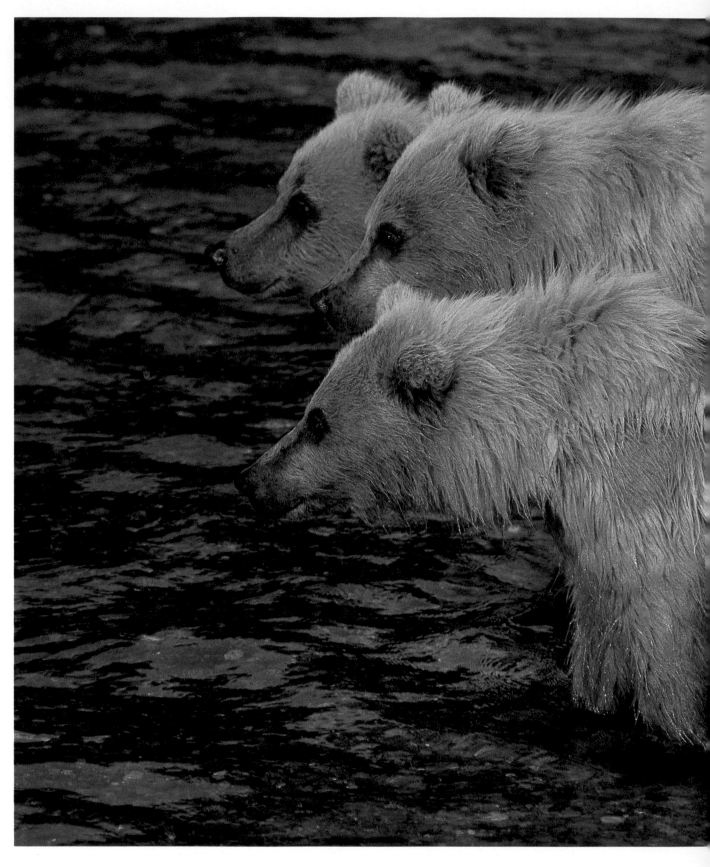

BROWN BEAR CUBS
Nikon F4, Nikon 500mm lens, Fujichrome 100

There they were, the three little bears, quickly dubbed "Larry, Moe, and Curly" for their actions and reactions. They came in with their mother to the falls on Brooks River in Katmai National Park. She would fish for sockeye salmon; they would stand and not so patiently wait for her return. One, the bravest, would eventually be unable to contain himself and would venture farther and farther into deep, swift water, short legs just touching the bottom. Then, oops, there he would go, floating off backward downriver, head bobbing along in the current. Five minutes later, he would be bounding back along the shore trail to take his place in line. Mom and the other kids never seemed to notice his disappearing-bear act.

Generally they stayed on the other side of the river, little bears tucked in against the rock face where they normally walked down to the water. But one afternoon here they were, all of them, close by in a line. Suddenly motor drives were absolutely smoking, film blasting through. And as quickly as it happened, it was over. Mom took a fish, Junior floated off downstream, and photographers were happy.

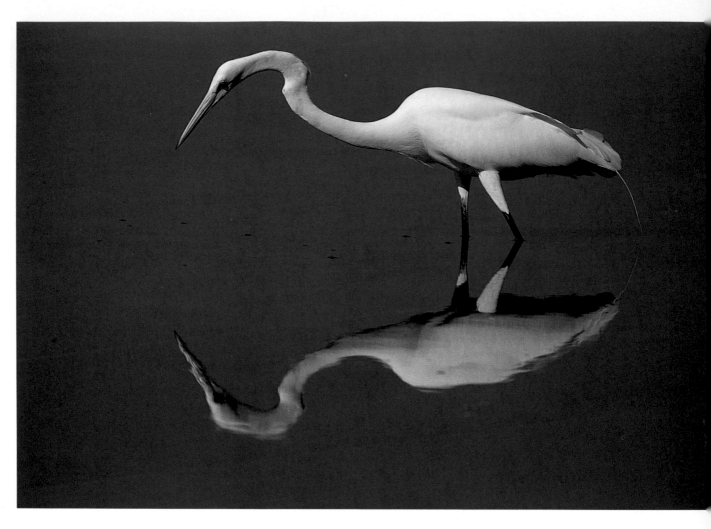

GREAT EGRET AND REFLECTION
Nikon F4, Nikon 500mm lens, Fujichrome 100

Sometimes you just get lucky. I'd almost given up for the morning. In fact, I'd packed my equipment and was driving out of the refuge when I saw 20 or 30 great egrets come flapping over and drop as a group into the shallows right next to the road. No other bird was in the area, so if the egrets hadn't landed just then I would have driven by without a moment's hesitation. But their arrival prompted me to slam on the brakes and grab for camera, lens, and tripod all in one motion.

My luck held. I worked my way to the water's edge and shot like mad—pairs of birds, single birds, birds with reflections, birds and more birds. Best of all, the exposure I had to use also worked in my favor. The egrets had landed in an area where the water reflected the light, milky-blue sky of that humid day. But I knew my film would record it differently. To hold detail in the white birds, I stopped down 1 stop from the unmetered "sunny *f*/16" values. As a result, everything in the frame recorded 1 stop darker. The light blue water became a rich medium blue in the slide. Sometimes you just get lucky.

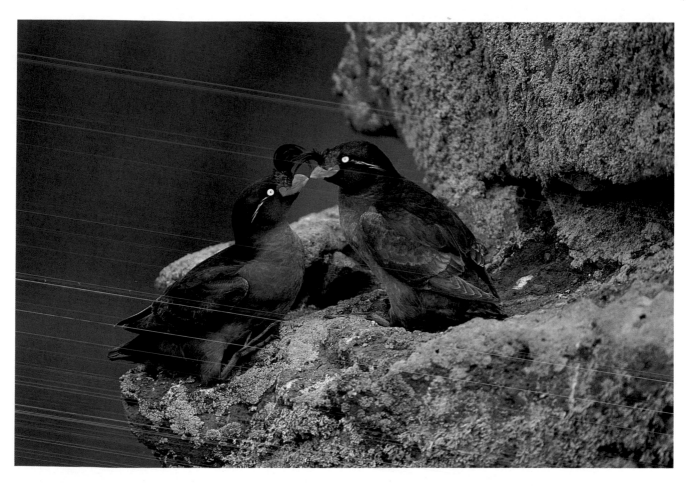

CRESTED AUKLETS
Nikon F4, Nikon 500mm lens, Fujichrome 100

I was sitting on the very lip of the vertical cliff edge at St. George in Alaska's Pribilof Islands. As the ocean waves broke rhythmically against the rock face 150 feet straight down, two crested auklets landed on the rock right next to me. Even with a short extension tube on my 500mm lens, I was below the lens' minimum focusing distance. So bundled against the cold arctic wind, I awkwardly tried to ease away from the birds, pulling my tripod and lens along and tossing my pack behind me.

Auklets have dense, waterproof plumage and dive and swim for their food. Along with guillemots, murres, murrelets, and puffins, auklets constitute the Alcids and are the northern ecological counterparts of the penguins of the Antarctic. But unlike penguins, these stubby little seabirds can fly. Fortunately, these two auklets stayed put. And in fact, they ignored me after their initial scrutiny. They were definitely more interested in each other, billing and cooing for at least 10 minutes before literally rolling off the cliff together into a tandem flight back out to sea.

THE PASSING MOMENT

LATE-AFTERNOON STORM
Nikon F4, Nikon 50–135mm zoom lens, Fujichrome 50

SOME EVENTS LAST JUST A SHORT TIME. THEY ARE HERE TODAY AND GONE LONG BEFORE TOMORROW IS EVEN A CONSCIOUS THOUGHT. CHANGE AND VARIATION SEEM TO BE THE ONLY CONSTANTS IN LIFE. YOU CAN'T TAKE THE TIME TO LOOK AT SOMETHING TWICE; YOU'LL HAVE ALREADY MISSED IT. THE LATE LIGHT HAS FADED, AND THE LARK HAS FINISHED ITS SONG.

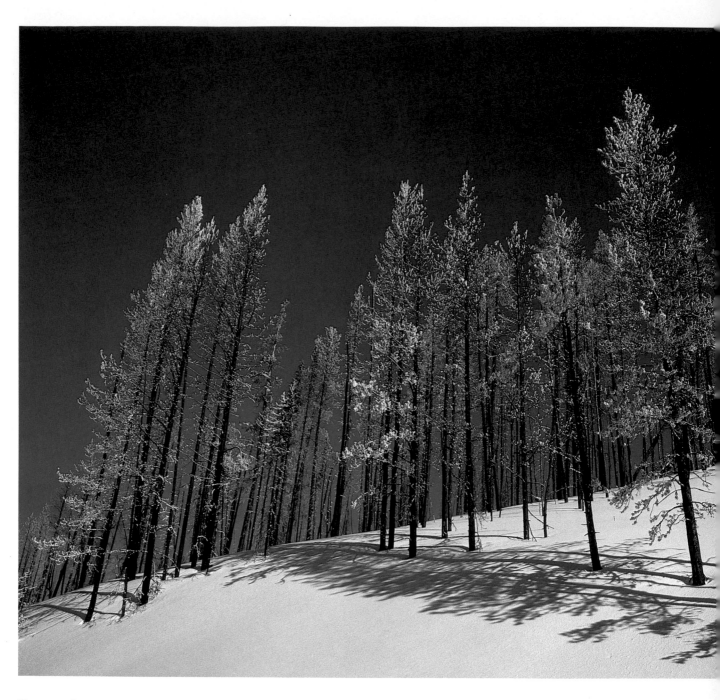

FROST ON LODGEPOLE PINES
Nikon F4, Nikon 24mm lens, Fujichrome 50

During a tour of Yellowstone National Park one winter, the group I was leading stopped to photograph a frosty thermal area along the park road. I immediately noticed these flash-burned lodgepole pines, and I liked the way the grove was outlined with white against the pure blue sky.

I needed to shoot up at the trees with a short lens, but from the road I wasn't able to include all of them in the frame. To back up far enough, I had only one choice: to plunge into a snowdrift. So I figured out where I wanted to shoot from and took a flying leap. Half of me disappeared into the deep snow. At least I landed in the right spot. With my 24mm lens, I was able to frame all of the trees and let the keystoning effect of pointing a wide-angle lens upward work to my benefit. My shooting position also enabled me to play the bottom shadow against the line formed by the hillside horizon. This photograph isn't polarized. The sky is a rich blue because I had to stop down in order to hold detail in the white snow. A polarizer would've deepened the sky even more, to black.

FROST ON GRASS
Nikon F3, Nikon 105mm macro lens, Kodachrome 25

An absolutely still, cold morning left me chilled but happy. When I first looked outside at daybreak, I realized that the heavy frost wouldn't last long. Luckily, I knew of an open, low meadow just a few miles away. I suspected that the frost would be even thicker there. After quickly driving to the meadow, I was relieved to see that it was coated in white. I grabbed my camera bag and tripod and jogged into the field, scouting for good places to shoot. I liked this area around an old fallen log where the frost clung thickly on the grass. The dark line of the log provided a diagonal across the frame, thereby adding a strong compositional element.

I'd left my house in such a hurry to capture the frost that I hadn't prepared for the cold. For the first 15 minutes of shooting, the adrenaline rush of excitement kept me warm. But standing fairly inactively behind a viewfinder and handling a metal tripod took their toll. I was chilled through and through before I left the meadow, but the resulting images were worth the discomfort.

EASTERN MEADOWLARK SINGING
Nikon F4, Nikon 500mm lens,
Fujichrome 100

One of my favorite bird songs is that of the meadowlark. Every time I hear it, I get sentimental and remember a farm that I lived on. So I photograph meadowlarks whenever I get the chance, and I try to capture them during the height of their song. Over the years, I've learned that a fast shutter speed is everything. You need at least 1/500 sec. to freeze a singing bird's lower bill; any slower shutter speed will record it as slightly blurred. Any image of the meadowlark can't or, I think, shouldn't, be anything but as crisp as the bird itself is, resplendent in gold and black.

One of the easiest ways to photograph meadowlarks is from a car that is used as a movable blind. I find a fenceline where the birds are singing and ease along with the engine just idling. My camera and lens are ready for shooting, and I use a bean bag or some other support for the lens. I then allow the car to drift into position, turn off the ignition, and prepare to shoot quickly. Whether or not I get any great pictures, I hear that splendid song.

BALD EAGLE ON SNAG
Nikon F4, Nikon 500mm lens,
Nikon 1.4X teleconverter, Fujichrome 100

"Be here at 4:30 this afternoon if you want to photograph the eagle on that there snag. It's gone by 5:00, so don't be late." I couldn't believe what I was hearing. A bald eagle would show up in this man's backyard on a precise timetable? Although I might have been a bit of a "doubting John," I was waiting with a fresh roll of film in my camera and my lens aimed at the branch long before the eagle was supposed to arrive.

Apparently there was a nest in a swamp a couple of miles away, and the two adult birds had been using this particular dead branch as a perch in the afternoon. Sometimes one eagle showed up, sometimes the pair did. I understood why the eagles had chosen this pine—it was taller than any other nearby tree—but I didn't understand the precision of their timing. That was just too much to believe. And I was right: the eagle didn't arrive at 4:30; it was at least 4:45, and the bird stayed until after 5:00 Still, that was long enough for me to burn up several rolls of film. Now if I could just organize other creatures to cooperate in this manner. . . .

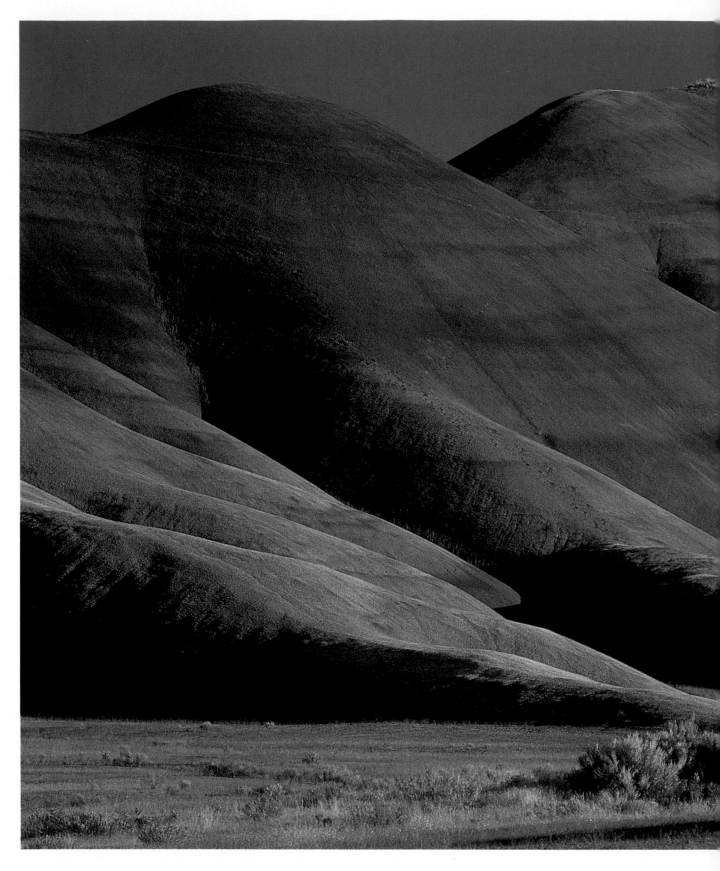

PAINTED HILLS
Nikon F4, Nikon 50–135mm zoom lens, Fujichrome 50

The Painted Hills section of Oregon's John Day Fossil Beds National Monument is an area of ancient volcanic-clay hills with striated colors and little vegetation on the hills themselves. Its isolation was clear to me the first time I visited the area. I was the only person at the Painted Hills for three entire days one July. Because this national monument is one of the most overlooked, perhaps it will be preserved relatively undisturbed. But the Painted Hills section is so beautiful in the right light—especially after a storm or late in the day—that I think everyone should see it.

The area needs to be seen in strong light, but not just any light will do. For less than an hour each day, the warm sidelighting of the late afternoon brings out colors and textures that are lost earlier in the day. If you visit the Painted Hills toward the end of the afternoon, you'll always carry that image with you.

RAINBOW AND ROCKS
Nikon F4, Nikon 50–135mm zoom lens,
Fuji Velvia

Since a rainbow forms when the sun shines through raindrops to create a prismatic effect, then a better description of this photograph might be a "snowbow." Before the snow started, dark clouds had rolled in and filled the sky; I gave up shooting for the day and hiked back to my truck. While I put my gear away, I noticed a small band of open sky on the horizon, right where the sun would pop through before setting. High in the mountains of Colorado, I decided to wait to see how the light would look. In the meantime, a slushy snow began to fall and continued for almost 20 minutes. The storm moved east just minutes before the light appeared, and then the rainbow formed. I had only a few moments to shoot before the sun dropped below the horizon and the show was over.

Saguaro cacti are formidable. Not only are they large, dominating their environment, but they also carry quite an array of weaponry. Cactus spines are actually modified leaves that serve several other purposes in addition to warding off nibbling animals and wayward photographers. Because there are so many spines, they provide shade from the relentless desert sun. The spines also form a barrier to help protect the cactus from desiccating winds and help create a microclimate to prevent the plant from freezing in cold weather.

The spines look best when illuminated by direct sidelighting, which occurs at sunrise and sunset. I wanted to show a line of them, so one morning I carefully positioned my camera to keep the film plane parallel to one of the cactus' ribs. I would've preferred to use a lens with a longer focal length, but I didn't have any with me. I've always maintained that when you are in the field, whatever equipment you have with you right then and there is perfect.

SAGUARO CACTUS SPINES
Nikon F4, Nikon 105mm macro lens, Fujichrome 50

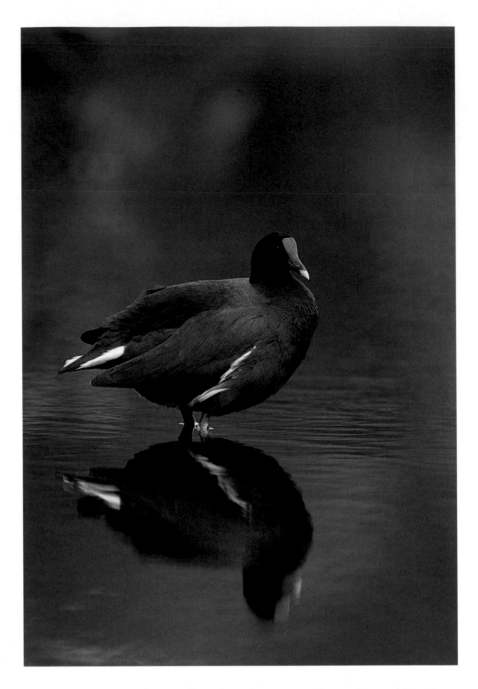

COMMON MOORHEN
*Nikon F3, Nikon 400mm lens,
Fujichrome 50*

For just one moment, this moorhen glanced over at me. I was photographing it along a drainage ditch through the mangroves near the Ding Darling National Wildlife Refuge exit. While these birds are fairly common throughout the southern Florida ecosystem, they're often overlooked simply because they are such a familiar sight. Sometimes people forget to look at what is right in front of them.

Whenever I can, I try to photograph birds and mammals from close to their eye level. Too many pictures of them are taken from about a 5-foot-high point of view, which is human eye level. Birds and animals exist in their own special worlds and have their own ways of looking at their surroundings. Try to photograph them from their perspective.

Shooting at bird's-eye level, however, meant locating my tripod almost in the water. I used my 400mm lens in order to crop tightly on the bird. Luckily the moorhen wasn't moving around much, so I could take the time to carefully maneuver my tripod and camera into the exact shooting position I needed. I wanted to isolate the bird against the dark green reflections of the surrounding mangroves.

There is a brief time between summer and fall that isn't of either season, but a separate, distinct interval. Although the deciduous trees are still green, their branches are just starting to bleed color. Birds and mammals begin their frenetic autumn pace. And ferns, such as these bracken, show their allegiance to both the past and the future.

To record their green and gold coloring, I used both my view camera and my 35mm equipment. While a tilting lensboard on a view camera helps you to align the plane of focus, it doesn't solve every depth-of-field problem unless the subject is all on one plane. You still have to stop down (as you must with all cameras) to get the parts of the subject that are on either side of the plane of focus sharp. Keep in mind, however, that focal length is always the same. For example, a 65mm lens on a 6 x 7 view camera provides the same depth of field at any given f-stop as a 65mm lens does on a 35mm camera. But to achieve the equivalent depth of field with an equivalent lens, which is roughly a 32mm lens on my Nikon, I have to stop down my view-camera lenses a couple of more stops. This is when the slightest wind becomes very noticeable. And a perfectly calm day is a rarity.

BRACKEN FERNS
Horseman 985, Schneider 65mm lens, Fujichrome 50

If you saw this lake in the middle of the day, you wouldn't even glance twice at it. In fact, you might try to avoid looking at it altogether. This lovely little lake, this serenely beautiful spot with reeds glowing in the morning mist—well, it's really an abandoned barrow pit where a county highway department dug gravel to use as fill along its roads. There is an old, junked truck camper dumped off in the weeds to one side, and local teenagers have left beer cans scattered.

But at one time of day, just at sunrise, this gravel pit becomes pristinely exquisite. Be here then and images stand out. In fact, I've published dozens of photographs taken at this pond, as have several other photographers who've worked here. I would dare to say this is one of the most photographed and most published gravel pits in the world.

This particular morning, the early mist diffused the light, making the entire pond glow orange. I wanted to show the whole area, so I used my 24mm lens stopped down almost all the way. I metered the water itself, then opened up 1 stop to render it as the light tone that it was in reality.

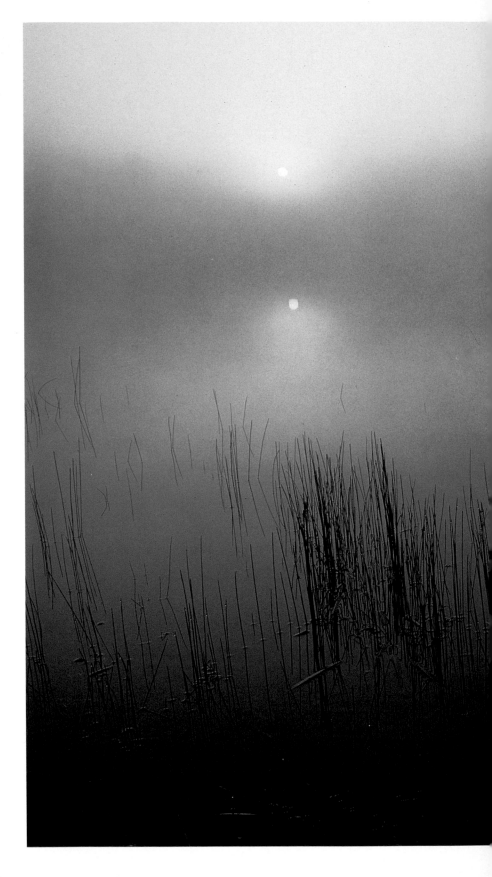

SUNRISE OVER SMALL LAKE
Nikon F3, Nikon 24mm lens, Kodachrome 25

THE HUMAN TOUCH

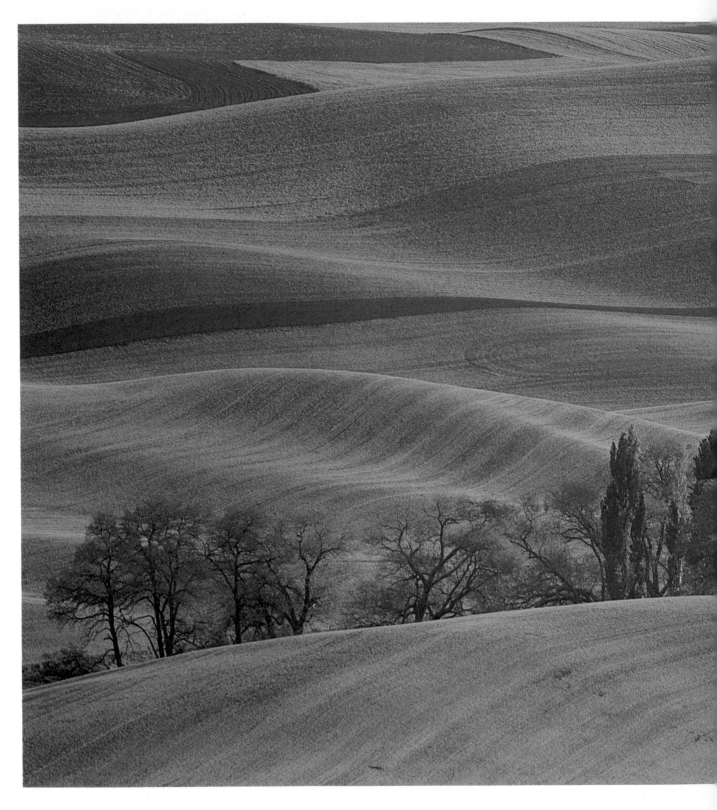

WHEAT FIELDS AND TREE LINE
Nikon F4, Nikon 200mm lens, Fujichrome 50

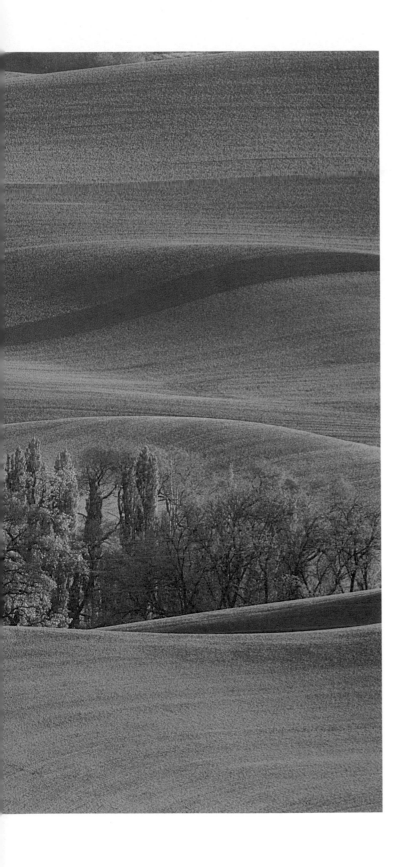

During camera-club competitions, nature photography is often defined as not showing "the hand of man." I've always thought that separating nature and people was a rather arbitrary and disturbing division. Aren't we, too, part of the natural process?

FENCELINE AND BROOM SEDGE
Nikon F3, Nikon 80–200mm zoom lens,
Fujichrome 50

I own just two zoom lenses: a 50–135mm lens that I love, and an 80–200mm lens that I generally carry only on trips during which I expect to be photographing primarily birds and mammals. I don't use zoom lenses often; this is simply because I carry other lenses within the range of my zooms and hate to double up focal lengths, not because zooms are bad. But zoom lenses come into their own when you shoot scenics. Having the ability to precisely crop the frame without having to change your shooting position is quite helpful.

I discovered this fence one spring day while driving through Cades Cove in Great Smoky Mountains National Park. I needed to shoot from right next to the road; if I'd walked toward the fence, I would've changed the perspective, lost elevation, and been unable to keep the fence isolated against the green field. The only solution was to shoot with my zoom lens from one spot. I tried several different compositions before settling on this one. Still including the line of broom sedges across the top of the image but cropping out those in the bottom left, I looked at the upper right section of the frame using the long end of my zoom lens. This unbalanced the image; the line of warm-colored sedges at the top was too strong. Zooming back to a shorter focal length, I added the sedges in the bottom and at the same time reinforced and lengthened the strong diagonal line of the fence.

WHEAT FIELD AND TANSY
Nikon F4, Nikon 50–135mm zoom lens,
Fujichrome 50

One of my passions in life is to simply roam around exploring an area. Every map I've ever held seems to speak to me as an invitation to adventure. I've never found a dirt road that I didn't want to follow. Take me off the interstate highways, plunk me down in some isolated rural area, and turn me loose. I think that having no set schedule, no definite destination, and no time constraints is absolutely perfection.

That is the background of this photograph. I was wandering through the Palouse farming area of eastern Washington, just poking along back roads with no particular place to go. Summer wheat and lentils were ripening everywhere. I shot a great deal of film in order to capture the colors and textures of field patterns. When I found this area, I was struck by the contrast between the tansy and the subtle lines of the various shades of ripening wheat. At the same time, the sky had an unusual color cast to it, caused by the blowing dust that diffused the light. I used my 50–135mm zoom lens at about the 50mm length to precisely frame the area I wanted to include.

These petroglyphs are on a rock wall near the old Wolfe ranch in Utah's Arches National Park. Finding them requires some effort because they aren't immediately visible on the trail. Both petroglyphs and pictographs are reminders of the Indian peoples who came into this country centuries ago. Putting it in simple terms, petroglyphs were carved into a rock while pictographs were etched or painted onto its surface. These particular petroglyphs have incredible detail: desert bighorn sheep, like the ones shown here, stand near men on horseback while a coyote runs past. Unfortunately, all of these markers of an old culture have been discovered by modern people who've riddled the wall with their own marks—including a bullet hole.

Photographing this petroglyph was very straightforward. Once I'd positioned my tripod, I used my zoom lens in order to achieve the precise cropping I wanted. The glyphs were deep within the shadow of a rock outcrop, so contrast wasn't a problem. I added a mild warming filter, an 81A, to my lens to counterbalance the blue expanse of the open sky.

Anasazi is the Navaho name for "The Ancient Ones," the ones who lived in this country long before Europeans came, the ones who were ancient even for the Navaho. Throughout the desert Southwest there are signs and symbols of this civilization, remains of their passing. Signal Hill is one of many locations where you can find petroglyphs, a graffiti if you will, which remind you of the Anasazis' journey.

I've photographed at this spot several times. A researcher told me there are at least 300 separate glyphs in the immediate area, and I've spent quite some hours just seeing how many I could find. But I always end up with a slightly eerie feeling. The petroglyphs are part of this desert, and I've tried to photograph them within the context of their surroundings. And yet. . . .

The best time to be at Signal Hill is sunset. The light isn't so harsh, the desert not so heated. Petroglyphs on the very top of the jumbled rock hill stand out in the slanting light. And if you can, be there by yourself. If you are, then be silent and listen. You'll hear wind through the saguaro spines, a far-off coyote, and perhaps distant voices of another people who were also on this hill long ago.

PETROGLYPHS
Horseman 985, Schneider 100mm lens,
Fujichrome 50

I've had a preconceived farm picture in my mind for some time: an isolated barn totally surrounded by a growing crop, no people or farm animals, no road to the barn, no machinery to be seen, no other buildings. Just barn and field standing alone and by themselves. The two are symbols of the rural dichotomy, sequestered isolation on one hand and independent strength on the other.

To my surprise, I found such a situation. A friend and I were driving along an agricultural back road, turned a corner, and literally there was the farm dead ahead. We'd been photographing other farms and barns in the area, and we'd discussed what we would like to discover; we both

had the same image in mind. Consequently as we saw this barn, we instantly jammed on the brakes.

Wanting to emphasize the expanse of the wheat field, I used a wide-angle lens, carefully shooting so that the open barn door was a solid black square. I shot with my 35mm lens rather than with my 24mm lens because I wanted to use a polarizer. The wider-angle lens shows a very pronounced uneven effect across a horizontally framed sky when polarized, as one side is more on-axis with the sun than the other. I prefer to keep the sky one even tone rather than it being light on one side of the frame, dark on the other.

OLD SCHOOLHOUSE AT DAWN
Nikon F3, Nikon 24mm lens, Kodachrome 25

I used to live in north-central Michigan near this old, long-abandoned schoolhouse. I never thought much of it until I drove past it just before dawn one February day. Its silhouetted shape appeared to jump out at me. As the schoolhouse materialized from out of the darkness, it seemed to be as much a part of the landscape as the nearby winter trees. Both had seen the years come and go, both had seen the changes in that part of Michigan.

I returned to photograph the school the next cold, cloudless morning. I wanted to work at the very first light, so I arrived at the spot long before dawn. I metered the light in the sky right next to the edge of the school's silhouetted shape. Because it was still quite dark and I needed to shoot at a fairly small aperture, I allowed for reciprocity failure. Using my 24mm lens with my tripod as low as it would go, I shot up at the school. This angle produced something of a keystone effect, tilting the already slanting walls so that they started to converge, emphasizing the lines leading to the empty belfry.

BARN IN WHEAT FIELD
Nikon F4, Nikon 35mm lens, Fujichrome 50

Did you ever have part of a distant landscape leap out at you and scream, "Here I am! Look at me! Come find me and photograph!" That is exactly what happened when a friend, Joe Van Os, and I were standing on top of Steptoe Butte, just north of Colfax, Washington. It was early summer, and we'd just driven for hours through endless green wheat fields. Suddenly, we simultaneously spotted this brilliant mustard field in the distance; in our excitement, we almost sprinted back to the car. Half an hour later, after we navigated farm roads by dead reckoning, there was this beautiful mustard field in front of us.

As I set up my tripod and camera, what amazed me most was the graphic repetition I saw. The plowed earth, the mustard field itself, and the cirrus clouds had curves that mirrored each other. I took a series of photographs of the curves that are fine, but the scene needed something to break up the green foreground. Just then a small cloud passed near the sun, throwing a shadow on part of the field, and a perfectly positioned highlight outlined the same curving shape. As my friend said, it was "the makings of a miracle."

MUSTARD FIELD
Nikon F4, Nikon 50–135mm zoom lens, Fujichrome 50

THE WORLD AROUND US

TUMBLEWEED SUSPENDED BETWEEN SANDSTONE WALLS
Nikon F3, Nikon 50–135mm zoom lens, Fujichrome 50

WE ARE SURROUNDED BY
BEAUTY AND LIVE IN A
WORLD OF WONDER, IF
ONLY WE TAKE THE TIME TO
SEE WHAT IS ALL AROUND US
AND PERMIT OURSELVES TO
FEEL DEEPLY AND
GENUINELY. IN THE
SMALLEST DETAIL WE MIGHT
DISCOVER TRANQUIL
HARMONY, AND IN THE
LARGEST EXPANSE ELATION
AND JOY. WE CAN FIND
MEANING AND VALUES IN
CARING FOR THE EARTH AND
ITS CREATURES.

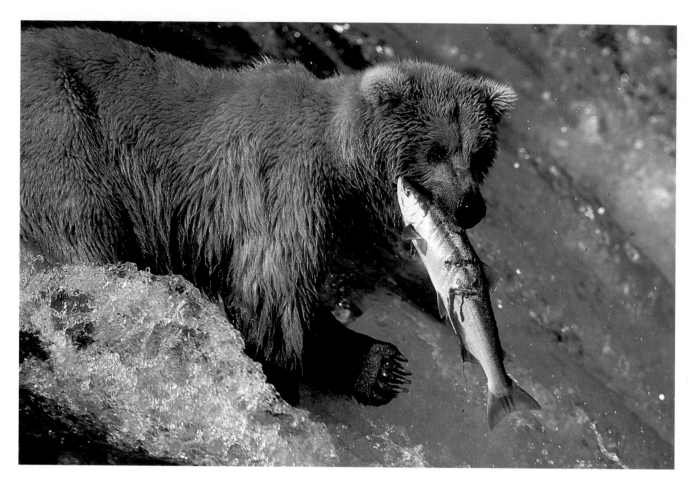

ALASKAN BROWN BEAR WITH NEWLY CAUGHT SALMON
Nikon F4, Nikon 500mm lens, Fujichrome 100

ICE ON TREES
Nikon F3, Nikon 35mm lens,
Kodachrome 64

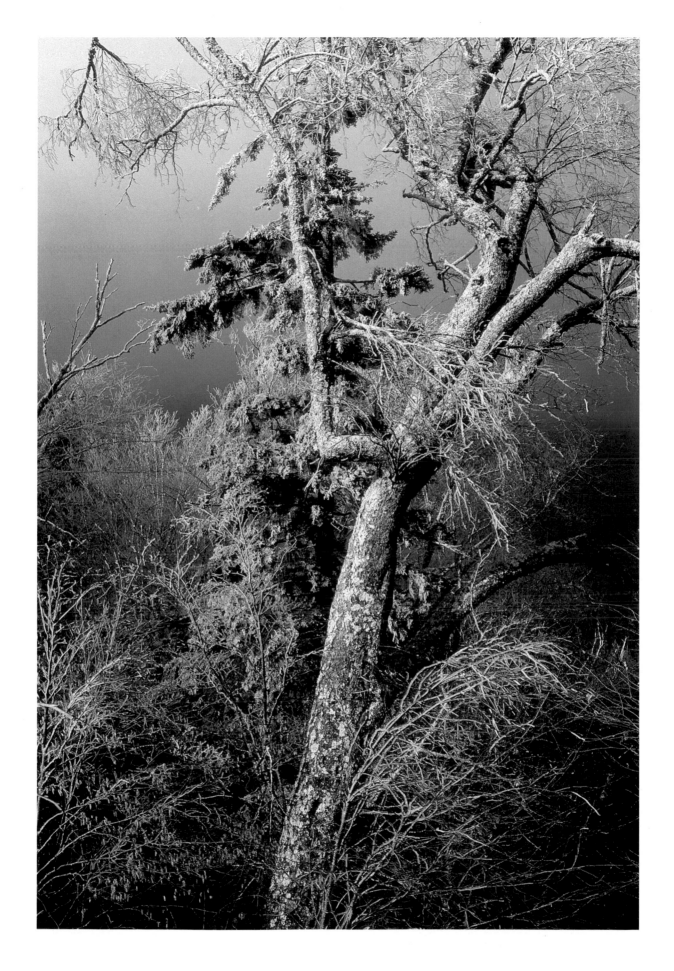

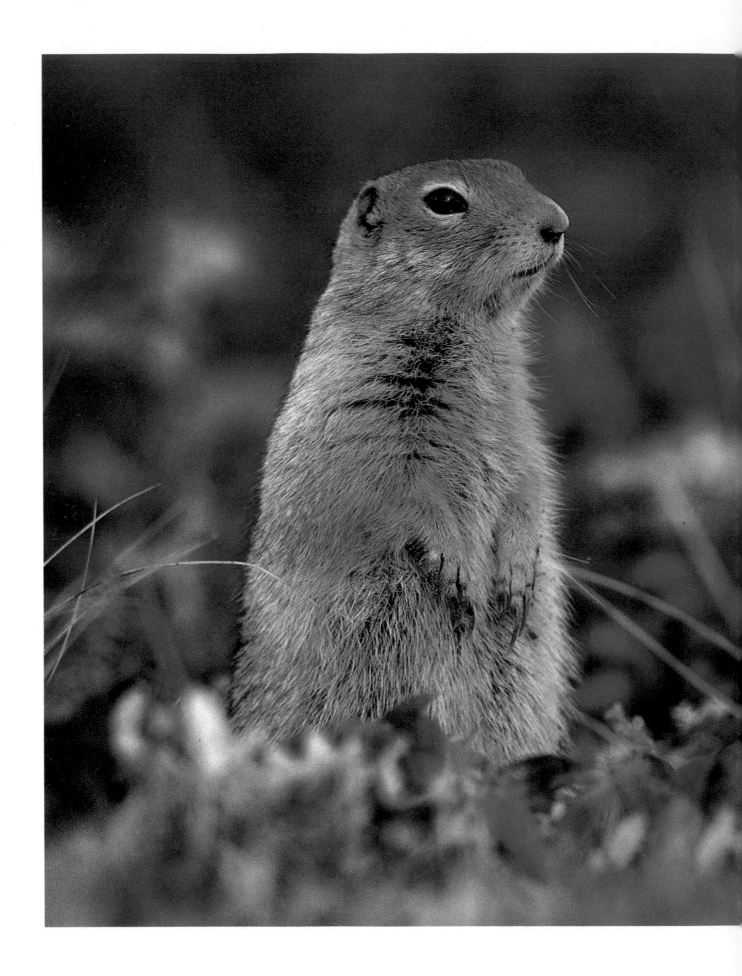

ARCTIC GROUND SQUIRREL
ON AUTUMN TUNDRA
Nikon F4, Nikon 500mm lens,
Fujichrome 50

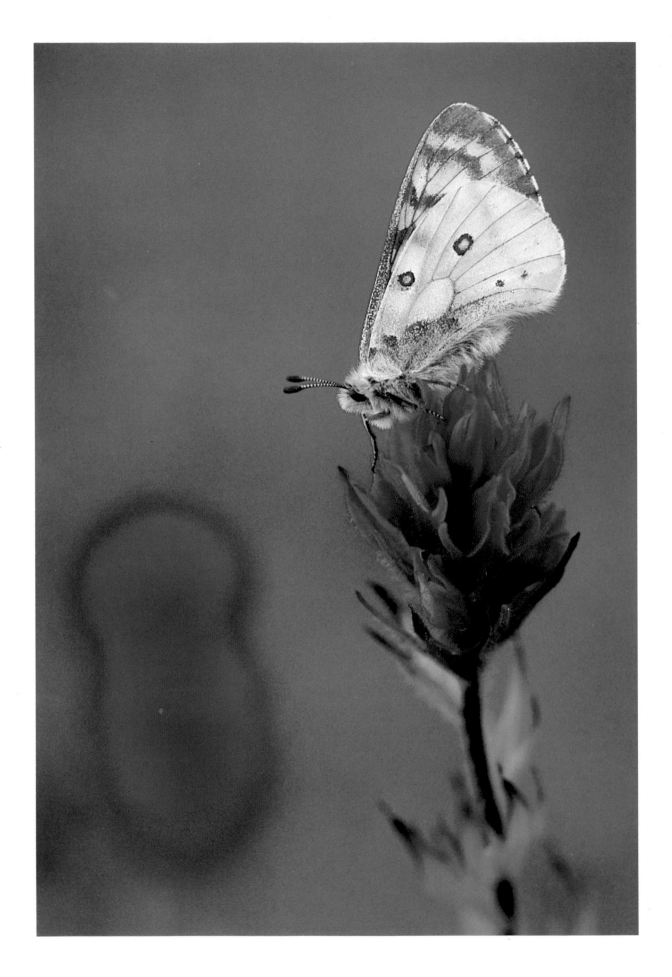

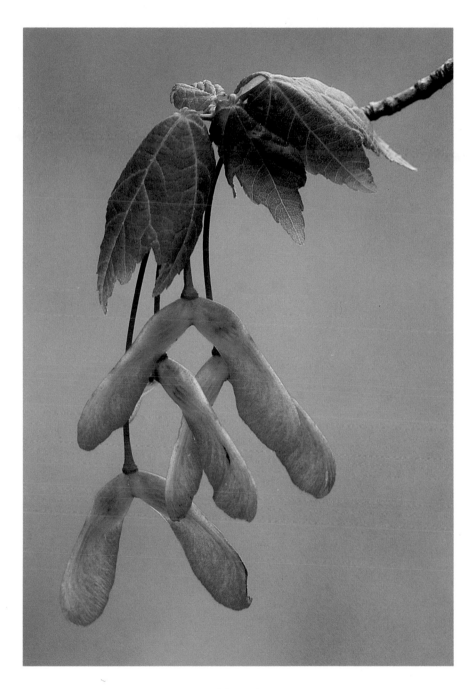

RED-MAPLE SEEDS
Nikon F4, Nikon 200mm macro lens, Fujichrome 50

PARNASSUS BUTTERFLY ON
MAGENTA PAINTBRUSH
Nikon F3, Nikon 50–135mm zoom lens,
Nikon 5T closeup diopter lens, Fujichrome 50

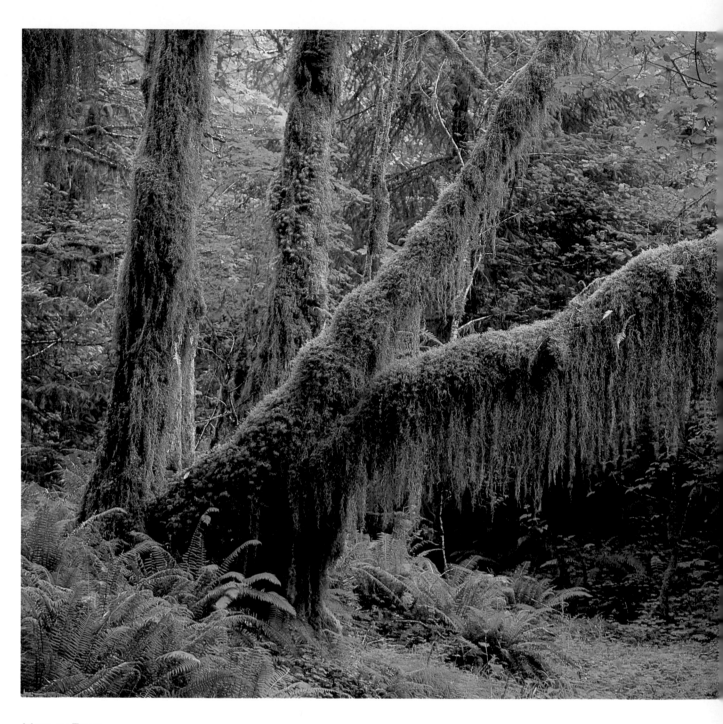

MOSS ON TREES
Nikon F4, Nikon 50–135mm zoom lens, Fujichrome 50

CANADA GOOSE IN DUCKWEED
Nikon F3, Nikon 180mm lens, Kodachrome 64

LEAFY SPURGE
AND SHEEP SORREL
*Nikon F4, Nikon 35mm
lens, Fujichrome 50*

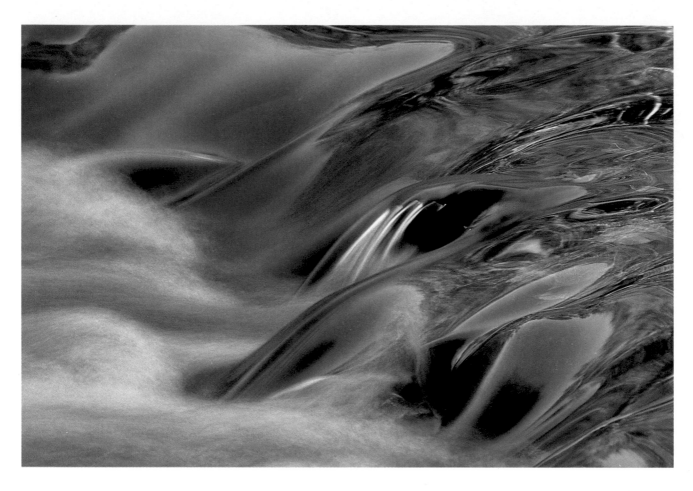

AUTUMN COLORS REFLECTED IN SMALL CASCADE
Nikon F3, Nikon 300mm lens, Fujichrome 50

SUNRISE REFLECTION
IN SMALL LAKE
Nikon F3, Nikon 105mm lens,
Fujichrome 50

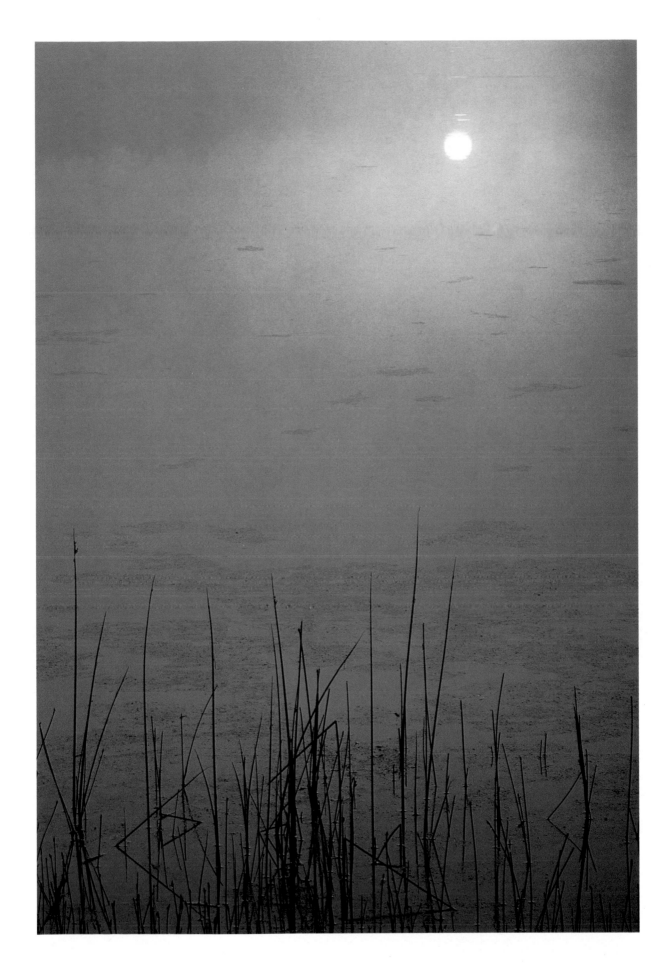

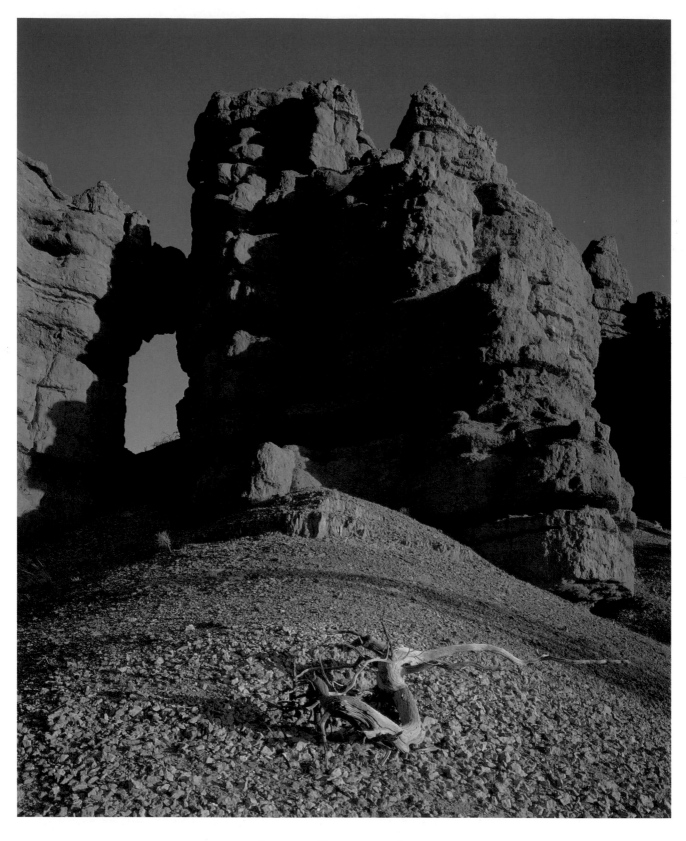

SANDSTONE FORMATION AT SUNSET
Horseman 985, Schneider 150mm lens, Fujichrome 50

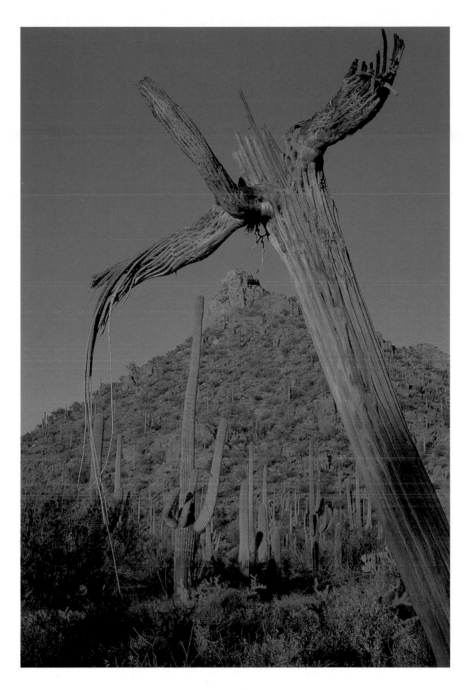

DEAD SAGUARO CACTUS AT SUNSET
Nikon F4, Nikon 24mm lens, Fujichrome 50

DESERT PAINTBRUSH AND SANDSTONE
Horseman 985, Schneider 150mm lens, Fujichrome 50

INDEX

Autumn foliage, 25, 28, 61, 75, 76, 89, 90
Backlit shapes, 20
Bellows, 13, 41
Birds, 11, 54, 55, 67, 85, 100, 101, 106, 112, 135

Cactus, 21, 111, 141
Cameras
 35mm, 13, 14
 view, 14, 113
Closeup lens, 20, 34, 67
Closeup photography, 32–43
Contrasts, 31, 35, 58–71
Cropping, 118, 120

Dawn. *See* Sunrise
Depth of field, 26, 47, 77, 93, 113
Desert, 8, 49

Equipment, 12–14

Farm scenic, 122, 124
Ferns, 35, 60, 65, 113
Film, 14
Filters
 polarizing, 14, 31, 37, 71, 122
 warming, 13–14, 120
Flowers
 closeups, 14, 26, 29, 37, 40, 80
 wildflowers, 56, 81, 119, 136–37
Focusing, 47
Focusing rail, 34, 39
Foreground objects, shooting from close to, 47
Frost, 52, 104, 105, 129
f-stop, 10, 26
Fujichrome, 14
Fuji Velvia, 14

Gitzo tripod, 13
Graphic elements, 19–32
Grasses
 barley, 95
 frost-covered, 105
 ice-covered, 83
 raindrops on, 42

Handholding, 42
Hyperfocal distance scale, 47

Ice
 -covered grasses, 83
 patterns, 42
Incident light meter, 55
Insects, 39, 64, 77, 132

Keystone effect, 104, 123
Kodachrome, 14

Lens
 bellows-only, 13
 closeup, 20, 34, 67
 long, 62, 88
 macro, 25, 26, 39, 40, 64, 77
 telephoto, 76
 wide-angle, 28, 47, 65, 104, 122
 zoom, 20, 22, 42, 83, 92, 118, 119
Light
 backlight, 20
 changing, 17, 23
 edge of, 49
 late afternoon, 88, 109
 first, 51
 overcast, 76, 85, 90
 sidelight, 31, 47, 109, 111
 sunrise, 62, 96, 114, 123

Macro lens, 25, 26, 39, 40, 64, 77
Mammals, 53, 58, 69, 78, 99, 128, 130
Metering, 40, 46, 51, 53, 61, 67, 93
 incident light meter, 55
 spot meter, 84
Mist, 52, 97, 114
Mountains, 23, 46, 51, 84, 97, 109

Negative space, 21
Nikon camera, 13, 42

Patterns
 ice, 42
 wood grain, 27
Petroglyph, 120
Photography, process and procedure in, 9–10
Polarizing filter, 14, 31, 37, 71, 122

Rain, 74
Rainbow, 110
Raindrops, 34, 43, 65, 66
Reflections, 89, 138, 139
Repetitions, graphic, 86–101, 124

Rock
 formations, 31, 71, 96, 140
 petroglyphs on, 120
 texture of, 31

Seasons, 72–85
Shadow, 22
Sidelight, 31, 47, 109, 111
Silhouetted shapes, 21, 123
Sky
 blue, 31, 104
 overcast, 76, 85, 90
Soft-focus shot, 40
Spot meter, 84
Sunny *f*/16 rule, 71
Sunrise, 16
 light at, 62, 96, 114
 reflection of, 139
 silhouetted shapes at, 21, 123
Sunset, 97, 120, 140, 141
Swamp, 65

Teleconverter, 64
Telephoto lens, 76
35mm cameras, 13, 14
Trees, 71, 93
 autumn foliage, 25, 28, 61, 75, 76, 89, 90
 frost-covered, 104
 ice-covered, 129
 moss-covered, 134
 overlapping branches, 92
 trunks, 22, 62
Tripod, 13, 54

View camera, 14, 113

Warming filter, 13–14, 120
Waterfall, 50
Wide-angle lens, 28, 47, 65, 104, 122
Wildlife photography
 birds, 11, 54, 55, 67, 85, 100, 101, 106, 112, 135
 at eye level, 112
 insects, 39, 64, 77, 132
 mammals, 53, 58, 69, 78, 99, 128, 130
Wind, 60, 95
Wood grain, 27

Zoom lens, 20, 22, 42, 83, 92, 118, 119